This is a modern introduction to the art of Thomas Gainsborough (1727–88), who was one of England's greatest artists and the creator with Joshua Reynolds of an independent English school.

Gainsborough has long been a popular and attractive figure in the history of English art, but this book shows that he was more than the well-known painter of *The Blue Boy*. His role as a prototype for the modern idea of the 'artist as Romantic' is discussed, while his deep knowledge of the art of the past is revealed to demonstrate his eclectic yet individual reworking of older styles.

Gainsborough's own personal style, based on the early eighteenth-century example of the French rococo, was developed by him into a highly imaginative art which – with his love of music – had analogies with musical improvisation. His engaging personality and artistic vision are discussed together as part of an all-round understanding of his place in the contemporary art scene. His complicated and sometimes tempestuous relations with the art world of his day are set against his very special personal relationships with some of his patrons.

The book is illustrated by seventy-five plates, in full colour. Their selection has been made from both paintings and drawings, the latter so important for a full appreciation of Gainsborough's art. The commentaries which complement the introduction provide an up-to-date and highly perceptive survey of his art and life for the scholar and general reader alike.

The paintings of Thomas Gainsborough

The Paintings of
Thomas Gainsborough

MALCOLM CORMACK
*Paul Mellon Curator, Virginia Museum of Fine Arts,
Richmond, Virginia*

The right of the
University of Cambridge
to print and sell
all manner of books
was granted by
Henry VIII in 1534.
The University has printed
and published continuously
since 1584.

CAMBRIDGE UNIVERSITY PRESS
Cambridge
New York Port Chester
Melbourne Sydney

Published by the Press Syndicate of the University of Cambridge
The Pitt Building, Trumpington Street, Cambridge CB2 1RP
40 West 20th Street, New York, NY 10011, USA
10 Stamford Road, Oakleigh, Melbourne 3166, Australia

© Cambridge University Press 1991

First published 1991

Printed in Singapore by Kim Hup Lee Printing Co Pte Ltd

British Library Cataloguing in Publication Data
Cormack, Malcolm
The paintings of Thomas Gainsborough.
1. English paintings. Gainsborough, Thomas, 1727–1788
I. Title
759.2

Library of Congress cataloguing in publication data
Cormack, Malcolm.
The paintings of Thomas Gainsborough / Malcolm Cormack.
p. cm.
ISBN 0 521 38241 6. – ISBN 0 521 38887 2 (pbk.)
1. Gainsborough, Thomas, 1727–1788 – Catalogs. I. Title
ND497.G2A4 1991
759.2 – dc20 90–19802 CIP

ISBN 0 521 38241 6 hardback
ISBN 0 521 38887 2 paperback

In memory
of
SIR ELLIS WATERHOUSE

Contents

Contents

Contents

Contents

Contents

Contents

Acknowledgements

In such a book as this, without footnotes, it is impossible to make proper acknowledgement to all the sources that have been used, but certain authorities can be generally thanked.

I must first express my gratitude for the work of and association with the late Sir Ellis Waterhouse and the late Dr Mary Woodall. From them both I was privileged to learn much, and not only about Gainsborough. Their example and research on Gainsborough should never be forgotten.

I am also deeply indebted to the encyclopaedic research of Dr John Hayes, who added to his general writings on landscape and Gainsborough the magisterial *Catalogue Raisonné* of Gainsborough's landscapes. No author on Gainsborough can but acknowledge his achievement.

Recent interpretations of Gainsborough, notably by John Barrell, Ronald Paulson, and Marcia Pointon, have provided further interesting ideas. The researches of Dr Brian Allen and John Bensusan-Butt, and the exhibitions at Gainsborough's House, Sudbury, organised by Hugh Belsey, have provided much useful information about Gainsborough's early years and his relationship with Hayman, which have helped somewhat to change the chronology of his early work. I have benefited from conversations with Rica Jones at the Tate Gallery's Conservation Department who has been conducting a survey of Gainsborough's early technique, and Elizabeth Einberg, Assistant Keeper of the Historic British Collection at the Tate Gallery. I am also in debt to discussions with Michael Rosenthal, and the constant help of Joy Pepe, Curatorial Assistant at the Yale Center for British Art, where the staff have, as always, been most helpful. Finally, I should like to thank my wife, Lynn, for her careful attention to details of the text.

Introduction

If we are impatient with the world's shortcomings, and believe it should be and can be put right immediately, then Gainsborough can be an annoying artist to consider as a fellow revolutionary. He clearly thought there should be time for reverie in art, as well as in life. If, on the other hand, we believe that the world is fairly well in order, with nothing much awry that a few like-minded, clubbable people can't put right around a table, then Reynolds seems to be our man. Gainsborough's mercurial temperament seems to set him forever outside the establishment circle.

Yet Reynolds wrote the first and most perceptive criticism of Gainsborough in his 14th Discourse to the students of the Royal Academy Schools, delivered in December 1788, after Gainsborough's death in August of the same year. Reynolds was the first President of the Royal Academy, of which Gainsborough had been a Founder Member in 1768, but Gainsborough had quarrelled with the Academy on at least two occasions in 1773 and 1784 – and after this last occasion he was never to exhibit there again. He seemed to shun all that Reynolds held most dear for the improvement of the status of artists in England, but Reynolds saw quite generously that, as he said:

> if ever this nation should produce genius sufficient to acquire to us the honourable distinction of an English School, the name of Gainsborough will be transmitted to posterity, in the history of the art, among the very first of that rising name ...

He went on:

> For my own part, I confess, I take more interest in and am more captivated with, the powerful impression of nature, which Gainsborough exhibited in his portraits and in his landskips, and the interesting simplicity and elegance of his little ordinary beggar children, than with any of the works of that [Roman] School ...
>
> I am well aware how much I lay myself open to the censure and ridicule of the academical professors of other nations, in preferring the humble attempts of Gainsborough to the works of those regular graduates in the great historical style ... [Among contemporaries he may have had the British and American precursors of Neo-Classicism, Gavin Hamilton and Benjamin West, or the Frenchman, Jacques-Louis David in mind.]
>
> But we have the sanction of all mankind in preferring genius in a lower rank of art to feebleness and insipidity in the highest.

In one sentence Reynolds easily throws over the Grand Style that he had spent a lifetime promoting. His comments have added weight because Gainsborough's style and approach were so very different from his own. They were obviously, to a certain extent, rivals, particularly over the matter of royal patronage, but they are perhaps better seen as two complementary developments in eighteenth-century British painting, both of which were equally influential on the Romantic movement.

Reynolds was academic, backward looking to the great Italian masters of the past to whom, as his Discourses show, the young students of the Academy were directed for instruction. Gainsborough looked nearer at hand, most searchingly, among his immediate or near contemporaries in France, such as Antoine Watteau and Hubert Gravelot, in whose studio he had worked in London. In some ways he could be said to have prolonged the rococo style in England and turned it into something very personal and proto-Romantic, eventually a long way from the impersonal demands of the grand style of History painting. From the art of the past he paid careful attention mostly to Dutch artists of the seventeenth century who were not generally considered part of the academic canon. He had, however, his admiration for Van Dyck in common with Reynolds: 'We are both going to Heaven, and Van Dyck is of the party', he is supposed to have said.

Reynolds went to Italy at the outset of his career to learn the lessons of the Italian Renaissance and develop his notions of the Grand Style 'in the midst of the greatest works of art that the world has produced', as he described them. Gainsborough never went abroad, and he absorbed his Old Masters indirectly.

Reynolds attempted to raise the standard of English portraiture, which he knew was the only method by which an English painter could get regular employment, by imbuing it with a sense of the grand, or heroic style, and the use of quotations from other works of art. Horace Walpole found it necessary to defend him from a charge of plagiarism by describing his practice as a form of quotation which 'with a novel application of the sense has always been allowed to be an instance of parts and taste'.

Gainsborough, on the contrary, was forever complaining of his subservience to portraiture, when all he wanted was 'to take my Viola da Gamba and walk off to some sweet village when I can paint Landskips and enjoy the fag End of Life in quietness and ease ... '. Writing to his musical friend William Jackson, he fulminated against being beholden to the requirements of society portraiture:

> Damn Gentlemen, there is not such a set of Enemies to a real artist in the world as they are, if not kept at a proper distance. They think (and so may you for a while) that they reward your merit by their company and notice; but I who blow away all the chaff & by G— in their eyes too if they don't stand clear, know that they have but one part worth looking at, and that is their purse ...

He was, nevertheless, shrewd about the conflicting requirements of a modern portraitist. He wrote to the Earl of Dartmouth in 1771:

My Lord I am very well aware of the Objection to modern dresses in Pictures [which Reynolds had criticised], that they are soon out of fashion and look awkward, but as that misfortune cannot be helped we must set it against the unlikeness of fancied dresses taking away Likenesses, the principal beauty and intention of a Portrait.

He was careful to remind his friend, William Jackson, that in his art 'a Man may do great things and starve in a Garret if he does not conquer his Passions and conform to the *Common Eye* in chusing that branch which they will encourage & pay for'.

Reynolds was the first President of the Royal Academy of which Gainsborough was an argumentative Founder Member, arguing, mostly, for the sensitive appreciation of his own pictures; that they should be seen at the right height and in a sympathetic light. Reynolds' Discourses to the students are models of polished urbanity and common sense. Indeed, so well written were they that it was suggested they were composed by Edmund Burke, or Dr Johnson. Gainsborough thought highly of them, and their 'ingenious Author', but observed 'betwixt Friends Sir Joshua either forgets, or does not chuse to see that his Instruction is all adapted to form the History Painter, which he must know there is no call for in this country ... '.

Gainsborough's letters, on the other hand, are full of his heart, rushing along with fanciful ideas and profane language, tactless, merry, chaotic, and personal to the extent that most recipients had not the heart to destroy them, knowing that the whole man was there. His friends were musicians: Abel, the celebrated viola player, J. C. Bach, Giardini, and J. C. Fischer, the oboist and eventually his son-in-law; whereas Dr Johnson, Edmund Burke, Gibbon, and Dr Beattie – the weightier minds of the day – were Reynolds' acquaintances. Actually they also had certain friends in common, such as Garrick, the actor.

As we know from those Reynolds' appointment books which have survived, he hardly missed a day in his studio. Sitters arrive with the regularity of visitors to an efficient dentist's waiting room, every hour on the hour. To achieve his success he did not forbear to use means that suggest the public relations consultant, keeping a coach with liveried footmen, described by his assistant, Northcote, as a 'chariot on the panels of which were curiously painted the four seasons of the year in allegorical figures. The wheels were ornamented with carved foliage and guilding; the liveries also of his servants were laced with silver ... [It] would give a strong indication of his great success, and by that means tend to increase it.' It was said that he sent his sister, Frances, out in it, when he had not need of it, so that people would say, 'There goes Reynolds.'

One of Gainsborough's daughters could remark to Farington, the diarist, in contrast, that 'her father often exceeded the bounds of temperance and his Health suffered from it, being occasionally unable to work for a week afterwards ... He often wondered at Reynolds' *equal* application.'

In other words, Reynolds was strictly a professional, with a keen feeling for public relations, while Gainsborough seems more of an amateur in the English

tradition. He seemed to presage our modern ideas of the artist as a free spirit, not beholden to those who commissioned his works. To certain prospective clients of perhaps more sober disposition, a portrait by Reynolds was preferable, and 'a daub by Gainsborough would do' for the sitter's college, as the Countess Spencer thought. The Royal Family, on the other hand, much preferred Gainsborough, and his ability to catch a likeness was considered by his contemporaries to be superior to that of Reynolds.

The personal characteristics of the artist are important, because although, of course, social and cultural matters cannot be ignored, our sensitivity to his art must involve, first, some understanding of his individual intentions, the better to appreciate the visual choices he made within the broader context of patronage and painting in late eighteenth-century England.

He undoubtedly effected a revolution in taste and sensibility that can be ranked with the achievements of Reynolds, Turner, and Constable, but there is still some ambiguity in estimating his art. His reputation fluctuated somewhat, particularly immediately after his death, except perhaps for his 'fancy' pictures 'on which', as Hazlitt described in 1814, 'Gainsborough's fame chiefly rests'. By the end of the century, however, high prices were being paid for his large, mostly late, full-lengths. This may have begun as part of a taste for an idea of eighteenth-century elegance, which was fashionable between 1870 and 1890, and which Gainsborough's pictures seemed to embody. The taste culminated in the famous dealer, Duveen, manipulating one American millionaire against another to pay very large sums for Gainsborough's late paintings. The most famous example was perhaps *The Blue Boy* (Plate 35) sold by Duveen to Henry E. Huntington for £148,000 in 1923.

More recently attention has turned towards his earlier work, most notably when *Mr and Mrs Robert Andrews* (Plate 8) was sold by their descendants to the National Gallery, London, in 1960 for £130,000. With the growth of interest in less fashionable artists, such as Joseph Wright of Derby or George Stubbs, throughout the 1960s, his art began to be taken for granted, and his late paintings even to be considered sentimental, or what is worse, meretricious. More recently, the study of his art has become like a branch of archaeology, as his paintings are examined for their social significance and exhumed from their layers of time as artefacts that ought to, but do not quite, reveal the real plight of the rural poor. And this was for someone who claimed that the principal aim of his figures was to provide 'a little business for the Eye'.

Equally, for someone who was well known as an instinctive artist with, apparently, very little interest in literature, his works have been forced into a canon of dreary second-rate poetry which demeans his visual art, and in the long run may be irrelevant. It has also been claimed by certain literary critics that it is impossible to decide an artist's intentions, which are in any case only a minor part of the wider cultural ramifications of a painting. This is to mistake art for anthropology. We will not appreciate his art if we do not follow carefully what he did, what he thought of it, and where his feelings lay. Recent studies in the history

of eighteenth-century taste are possibly more useful in appraising how he instinctively felt the breezes of fashion, so that we can see how much he created them, or remained totally outside their range.

Gainsborough's problem, as with most English artists of the period, was that he was taught in an original way, with no true academic training. He became independent early on and then jibbed against what he had to do professionally, and in so doing created an art that has been admired the world over ever since as the embodiment of an independent English tradition of native genius. In an age such as ours, artists have, at best, a patchy sense of the past, but Gainsborough was a proto-Romantic, looking forwards and backwards with a clear sense of what he wanted to draw upon, however eccentric his choice. But equally, and typically for the eighteenth century when virtuosity was admired, he did not think that eclecticism was immoral in the creation of his own inspirational works.

Thomas Gainsborough was born in Sudbury, Suffolk in 1727, the youngest child of a family of five boys and four girls born to John Gainsborough (*c.* 1683–1748). The exact date of his birth is unknown, but he was baptised on 14 May 1727 at the Independent 'Great Meeting' House in Friar Street. The Gainsborough family had come to Suffolk from Lincolnshire in the seventeenth century, and were traditionally connected with the cloth trade in one form or another. The painter's uncle, Thomas Gainsborough (1678–1739), became a successful business man, whose son had a partnership in London and ventures in the West Indies; but his brother John, the painter's father, was in turn milliner, clothier, and maker of crêpe for funerals, and at one time ran a thriving shroud-making firm. But his business instincts were less sure than his brother's, and his lifestyle was more eccentric. He eventually went bankrupt. He was given the position of Postmaster at Sudbury, perhaps owing to the influence of his rich relatives, a post which his widow took over at his death in 1748, until her death in 1755.

Mary Burrough (1690–1755), the painter's mother, came from a staunch Church of England background, and this difference between her religion and her husband's Nonconformism seems to have affected relations among the family as a whole. Gainsborough seems never to have painted his father's Dissenting relatives, although he was to be grateful for their financial help at an early stage.

His upbringing and background are important because of the contacts the family had made in Suffolk and the fact that they gave him his first encouragement towards an artistic career. His mother's talent as an amateur flower painter may have helped. He was to remain in close touch with his brothers and sisters throughout his life. He was to help his eldest brother, John (1711–89), known as 'Scheming Jack', whose time and money were spent on impractical inventions such as a self-rocking cradle and a mechanical cuckoo. He was to remain close to his brother Humphry (1718–76), who became a Dissenting minister and an engineer of some talent; while his sister Mary (1713–*c.* 1790), who married Christopher Gibbon (1715–60), remained a confidante, particularly after her move to Bath in 1762, and secretly helped the artist with money. Another sister,

Sarah (1715–95), married Philip Dupont (*c.* 1722–88), a carpenter, whose son, Gainsborough (1754–97), was to become his only apprentice and studio assistant. Gainsborough was to paint all his near relatives, as well as his mother's brother, the Rev. Humphrey Burrough, and his clergyman son, Henry, and another son, Nathaniel. Humphrey Burrough was Rector of Borley, but also master at Sudbury Grammar School between 1723 and 1755, when the painter would have been one of his pupils for three to four years.

The lack of portraits on his father's side may have been due to the religious differences which possibly separated John and his wife from his brothers, but also, perhaps, to the general distrust of art with which Nonconformism has always been associated in Britain. The artist was less involved. He wrote to his sister, Mary Gibbon, in 1775: 'I told Humphry you were a rank Methodist, who says you had better be a Presbyterian, but I say Church of England. It does not signify what, if you are but free from hypocrisy, and don't set your heart upon worldly honors and wealth ... '

A few years earlier, about 1772, Gainsborough rather surprisingly had told a sitter, Sir William Johnstone-Pulteney (Plate 40), that 'I generally view my Works of a Sunday tho' I never touch.'

Good works (and hard work) rather than good things seemed to reveal the Nonconformist spirit behind his uncle Thomas' will in 1739, who left only five shillings a week to his brother John (Gainsborough's father), should he need it, and nothing to the painter's mother. The executors were to

> take care of Thomas Gainsborough another of the Sons of my brother John Gainsborough that he may be brought up to some Light Handy craft Trade likely to get comfortable Maintenance by and that they do give any Summe not exceeding Twenty Pounds to bind him out to such Trade and I leave it to my Executors if he shall prove sober and likely to make good use of it to give Ten Pounds over and above the Ten Pounds I have herein given him the better to enable him to get out into the world.

He and his executors may not have been pleased that Mary had decided to encourage her son's artistic leanings which were already apparent in Sudbury. According to Gainsborough's niece, Sophia Lane, the daughter of the artist's sister, Susan,

> An intimate friend of his mother's, being on a visit, was so struck by the merit of several heads he had taken, that he prevailed on his father to allow him to return with him to London, promising that he should remain with him and that he would precure him the best instruction he could obtain ...

Bate-Dudley, who knew Gainsborough well, stated that he was thirteen in 1740 when he left Sudbury for London. Gainsborough wrote to Bate-Dudley in 1788, writing of *Cornard Wood* (Plate 4) that it 'was actually painted at Sudbury in the year 1748; it was begun *before I left school* – and was the means of my Father's sending me to London'.

Gainsborough, in other words, was precocious, already painting either heads or

landscapes or at least beginning to paint landscapes at the age of thirteen, or so it would seem. There are other traditional stories of his early ability to draw caricatures of his school masters and to fake notes from his father to be excused school, and his friend, Philip Thicknesse, recounts a story that he said had been told to him by the artist:

> that during his *Boyhood*, though he had no idea of becoming a Painter then, yet there was not a Picturesque clump of Trees nor even a single Tree of beauty, nor no hedge row, stone, or post, at the corner of the Lanes, for some miles about the place of his Nativity that he had not so perfectly in his *mind's eye*, that had he known he *could use* a pencil that he could have perfectly delineated . . .

Constable was to write to J. T. Smith in 1799 in the same vein about the Suffolk landscape: 'I fancy I see a Gainsborough in every hedge and hollow tree'; and as he later wrote to Fisher in 1821: 'They made me a painter – that is I had often thought of pictures of them before I touched a pencil . . . '

Perhaps these should join the number of apocryphal stories about art, rather like Vasari's story of Cimabue discovering Giotto drawing perfect circles, or Claude-Joseph Vernet and Turner having themselves strapped to the mast, the better to observe a storm at sea. Nevertheless, a boy of thirteen would not have been apprenticed by an anxious mother in difficult circumstances, who had reasonable contacts in the cloth trade, to the art world of London in 1740, unless he had shown signs of talent.

His uncle's will had promised twenty pounds, for an apprenticeship, in 'some Light Handy craft Trade', so the mysterious 'intimate' friend apparently introduced Gainsborough to a silversmith. A recent suggestion by Adrienne Corri that he was paid a regular sum of £300 a year from 1736 when he was ten, by Claude Fonnereau (d. 1739), a retired merchant of Christchurch Mansion, Ipswich, seems unlikely. Gainsborough would not have needed to become an apprentice at the age of thirteen if he had an income of £300 per annum. On the other hand, her suggestion that Robert Andrews, a silversmith and rich father of Robert Andrews of Auberies near Sudbury who was painted by Gainsborough some time after 1748 (Plate 8), may have been the 'intimate friend' of his mother is not without possibility, but other names have been suggested. On the other hand, Adrienne Corri's publication of the painting of a youthful artist, as a possible early self-portrait, may be correct.

Yet what we know of Gainsborough's early career in London was of a young apprentice making his way into the art world slowly, with humdrum tasks that were an apprentice's lot. He is supposed to have modelled animals, and though we know he did this constantly, it may only have been as a way of learning, or possibly for silverware as John Hayes has suggested. He did not begin in an academic way drawing from the life, or copying casts, although he may have copied pictures and engravings after them, as his first beginnings were as a graphic artist.

His first master, whom his associate, Charles Grignion, later identified, was Hubert François Gravelot (1699–1773), the French engraver and draughtsman. Gainsborough was thus plunged into a journeyman's world of the graphic arts, then fashionably influenced by a French rococo style of which Gravelot had first-hand knowledge. He is supposed to have helped Gravelot with the ornamental surrounds for Thomas Birch's *The Heads of Illustrious Persons of Great Britain*. These surrounded portrait heads after earlier artists with decorative cartouches, and the publication was engraved by Jacobus Houbraken. The decorative setting for the portrait of *Francis Russell, 2nd Earl of Bedford*, after Knapton, is one that has been connected with Gainsborough, and is very close in its *rocaille* feel to French designs in publications such as the *Livre ornamens* of 1734 by J. O. Meissonier, Mondor's *Forme rocquaille*, 1736, or Babel's *Cartouches pitoresques*, *c.* 1743. They provided ample examples from which Gainsborough could learn the flowing line of French decorative details, and this decorative sense in some ways never left him.

He had entered the London art world at the time of the greatest interest in French art and design and, like English Post-Impressionist artists at the beginning of the twentieth century, 'he had the discoveries in his hands without having felt the passion of the search', but at least he was in the company of Gravelot who had been a pupil of Boucher. There was a craze for things French, led by artists in the circle of Frederick, Prince of Wales, and Watteau and 'Watteauesque' pictures were in great demand. This, in turn, led to a broader view of contemporary French art on the part of English artists. Lancret, Boucher (Plate 65), and Fragonard (Plate 14) were not without interest to Gainsborough later on, and, equally, visiting French portraitists such as Jean-Baptiste Van Loo, Roubiliac, and the pastels of Latour and Perroneau were to provide immediate and future examples to emulate. The general ramifications of French art in the English art community are too broad to discuss in detail here, but Gainsborough, initially through Gravelot, was not unaware of them throughout his career.

There were a number of genuine Watteaus already in English collections. Dr Richard Mead (1673–1753), the famous collector and founder member of the Foundling Hospital whom Watteau visited in 1719 in a vain search for a cure for his consumption, and Bragge, the dealer, owned genuine examples by him, but, as Reynolds remarked to Desenfans, the dealer, in the knowing way traders discuss hard times: '[Watteau's] works being extremely dear on the continent the brokers and dealers bring over copies of his pictures, or those of his imitators which they impose upon us as originals ... ' Robert Raines, in his exhaustive survey of the sale rooms during the period 1724–60, decided that this was probably true. Yet Watteau's designs were known to English artists in engraved form; the drawings published in two volumes in 1726 and 1728 through the agency of Jean de Jullienne, and the paintings, brought together in two volumes known as the *Recueil Jullienne*, in 1735. A number were borrowed as title figures for George Bickham's *The Musical Entertainer*, the famous illustrated

songbook. At the end of Gainsborough's life, his painting of *The Mall* (Plate 57) was recognised by his contemporaries as being influenced by Watteau.

A number of artists who worked in England, such as Peter Tillemans (*c.* 1684–1734), Philip Mercier (1689–1760), Bartholomew Dandridge (1691–*c.* 1755), Marcellus Laroon (1679–1772), and Joseph Francis Nollekens (1702–48), all produced works, as Brian Allen has demonstrated, in frank imitation of Watteau, some of which were even attributed to him, or they painted 'conversation pieces' where the generalised mood of a *fête galante* was translated into portrait groups of real people. These could all have been known to the young Gainsborough through his association with Gravelot.

Gravelot was, incidentally, often employed to provide small figures for book illustration, notably Samuel Richardson's *Pamela* (1742 edition) on which he collaborated with Francis Hayman, as well as foreground figures for Samuel and Nathaniel Buck's topographical views. These casual figures, sprinkled into the foreground according to taste, sometimes look out of place, with their French elegance set against pedestrian views of English towns, but they gave Gainsborough instruction in the use of such *staffage* which could provide 'a little business for the Eye'. Plate 2 illustrates an early Gainsborough drawing in the French taste. Such figures may also have contributed to his aversion to topography.

Gravelot's principal role for Gainsborough, before he left for France in 1746, was as a teacher at his own drawing school in James Street, Covent Garden, and as an instructor at the 'second' St Martin's Lane Academy. The Academy was a revival of 'Kneller's Academy' in Great Queen Street, and Thornhill's Academy, and was an attempt on the part of English artists to organise themselves, by providing life classes and other training, which at that time did not exist. Their efforts led to the formation of the Society of Artists in 1760, and eventually, in 1768, the Royal Academy, of which Gainsborough was to become a Founder Member.

Gravelot was also a member of 'Old Slaughter's Coffee House Set', which was described by Vertue as 'a rendezvous of persons of all languages and Nations, Gentry, artists and others'. Gainsborough was thereby thrust into the forefront of contemporary taste, through his association with Gravelot, and Francis Hayman (*c.* 1708–76), also an instructor at the St Martin's Lane Academy, and a convivial attender at Old Slaughter's, or anywhere else for that matter.

Hayman has been described as a teacher of Gainsborough, but there is no real evidence for this, except the obvious debt of Gainsborough to Hayman's conversation pieces of the early 1740s, the knowledge that Gainsborough must have acquired from Gravelot's and Hayman's collaboration with book illustration, and, most importantly, Gravelot's and Hayman's combined efforts in the extensive series of decorations for the pleasure grounds of Vauxhall Gardens, which, with the Foundling Hospital, provided for the young artist all that was new in British art.

Gainsborough's early conversation pieces combine all the elements of his early

experience. The 'conversation piece' in itself was not an English invention, but was developed out of Dutch and French portraits on a small scale to provide single figures, or a lively and intimate grouping of families together, indoors or out-of-doors, talking, or not talking, as the conversation piece has sometimes been described; interacting, or remaining frostily indifferent, as the case may be; venturing into the outside, to pose at ease (Plate 11), or with obvious deep suspicion of their natural surroundings (see Mrs Andrews in Plate 8); sometimes posed in obvious enjoyment with their sporting equipment (Plate 9), or aloof with a book in an artificial setting (Plate 10), as befits a teenager.

Gainsborough's early works exploit this middle-class desire to be shown naturally, but whereas Hayman's figures in this genre are large in scale compared to the landscape, Gainsborough's varied from small to large, from single to multiple groupings, and, as we know, from early on his technique was equally various and complicated. Nevertheless, such a group as Hayman's *The Jacob Family*, *c.* 1743–4, provided a typical example from which Gainsborough could learn, and was, at one time, even exhibited as a Gainsborough. When he first began, he was not averse to painting the landscape background for Hayman's small portrait of *Elizabeth, and Charles Bedford on a St Bernard Dog, in a landscape*, of *c.* 1746–7 (Private Collection), as a letter by Hayman reveals. It may not be the only instance of Gainsborough and Hayman working together. Indeed, their interaction seems to have progressed from the young artist helping Hayman, in, for example, a figure in his *Children Building Houses with Cards*, *c.* 1742 (Viscount Gort), and his help with the landscapes (it must be remembered that painters of these small figures were paid by the head, so that it was cheaper for Hayman to use Gainsborough for landscapes), to the situation at the end of the 1740s when, if Hayman's engaging portrait groups of Jonathan Tyers and his family, the promoter of Vauxhall Gardens, are compared with Gainsborough's groups of the same period (Plates 10, 11), Hayman's works seem conventional. For all his 'Frenchified' competence, Hayman seems to be learning from Gainsborough who had all the imagination and sensitivity.

Further important influences on Gainsborough's art must be mentioned. No artist in the 1740s would have been unaware of the presence of William Hogarth (1697–1764). He stood for an independent English artistic tradition, yet was very French in his leanings. His conversation pieces, with his sense of fluttering touch, his own versions of French boudoir art, for example, *Before* and *After* (Fitzwilliam Museum, Cambridge), and his championship of a sinuous curve of beauty, put him directly in line with rococo aesthetics, yet his individualism and anti-academicism also provided the young artist with an example of independence against the establishment that he never forgot.

Hogarth had, in fact, done much to help English artists to show their work. He had presented his full length of *Thomas Coram* to the Foundling Hospital in 1740, and the large paintings that he initiated to decorate the Court Room became a permanent exhibition of English art for everyone to see. He was to encourage Gainsborough, and it was through his influence that Gainsborough was invited to

contribute a landscape in 1748 (Plate 5). Gainsborough's debt to Hogarth was principally in the sensitivity to the sitter, expressed by a fluid handling of paint, but Gainsborough's portraits were never so direct, and his subject pictures never so satirical a comment on current affairs as Hogarth created. Reynolds flirted with caricatures, and then realised a portraitist would not survive by so doing. Gainsborough may have been tempted, but his excesses were not so obvious, or they became a private joke to himself (Plate 19).

Hogarth's influence shows that, together with French art, another direct tradition of realism was also current during the 1740s of which Gainsborough was well aware. The Netherlandish art of small cabinet pictures of everyday life, portraits on a small scale, landscapes with peasants, and seascapes was equally influential. They all influenced French art, and were, in turn, to influence English art, and, in particular, Gainsborough. Dutch painters were not supposed to be acceptable to academic arbiters of taste, either in France or in England. Horace Walpole castigated them as 'those drudging mimics of Nature's most uncomely coarseness', and other connoisseurs mentioned their 'labored productions', but everyone bought them, from the Duc de Choiseul in France to the massive importation during the period 1747–51 in England, as Iain Pears has shown. Gainsborough seems to have been involved in restoring them, imitating them, even, perhaps, faking them, during his early career. As the landscape artist that he hoped to become, he was never unaware of their implications. His earliest works, sold to dealers at trifling prices, seem to have been in this vein. The specific influence of, for example, Wijnants, Ruisdael, Jan Both, and Wouvermans, will be mentioned again.

With the departure of Gravelot to France in October 1746, Gainsborough seems to have set himself up as an independent artist in Hatton Garden, London, selling landscapes and drawings for whatever he could get. In the following year, on 15 July 1746, he was hastily married at Dr Keith's Mayfair Chapel to Margaret Burr. Farington in his diary (15 February 1799) said she was 'a natural daughter of Henry, Duke of Beaufort, who settled £200 a yr. upon Her'. Recent research by Adrienne Corri has shown that she may well have been a daughter of Frederick, Prince of Wales, and that the Duke of Beaufort was merely acting as his agent. Gainsborough was to be grateful for the £200 which was paid until Mrs Gainsborough died in 1798. The marriage at a chapel notorious for its clandestine weddings suggests that Margaret was pregnant, and a return to Sudbury would not have been proper. She did have a daughter called Margaret, who died young, and was buried at St Andrew's Holborn, Gainsborough's parish church, on 1 March 1747. He was to return to his home-town, Sudbury, shortly afterwards, possibly in connection with the death of his father on 29 October 1748. His daughter Mary was baptised at All Saints on 3 February 1748/9, and Margaret was baptised at St Gregory's on 21 August 1751.

Gainsborough was already working as an independent artist, and a number of small landscapes are known which seem to date from before his return to Sudbury. Gainsborough at the end of his life was modestly to call them his 'first

Imitations of little Dutch landskips', and they undoubtedly answered the subversive appeal of Dutch landscapes in their effects of dune scenes and winding roads, but they were wholly original and there is nothing quite like them in English art at that time. George Lambert (1700–65) occasionally came close, but his works were much more generalised, apart from two views of the 1730s painted for the Duke of Bedford, one in the Tate Gallery, another in the Yale Center for British Art, New Haven. Minor provincial landscapists such as George Smith of Chichester (1714–76) or the mysterious Arthur Nelson (fl. 1765–73) who worked around Dover in Kent have something of the same innocent gaze, but none has Gainsborough's natural feel for texture and light.

Gainsborough's earliest dated painting, the portrait of a bull-terrier called *Bumper* set in a landscape, is dated, according to a transcription on the relining canvas, 1745 (Bacon Collection). It invites comparison with John Wootton (1682–1764), who deserves better than to be written off as a pasticheur who provided large sporting pictures by the yard, and overdoors by the foot length, in the manner of Claude, or whatever was required. His lively scenes of hunts and race meetings at Newmarket, individual racehorses, and dogs have an immediacy which reminds us that contemporary patrons 'would rather see the portrait of a dog I know than all the allegories you can show me', while Ben Marshall remarked realistically at the beginning of the nineteenth century, that 'many a man who will pay me 50 gns. for painting his horse, thinks 10 gns. too much for painting his wife . . .'.

Gainsborough was doubtless well aware of this, yet his *Bumper*, commemorated by the owner as 'a most Remarkable Sagacious cur', has a sensitivity to the character of the dog, and its placing in a wooded landscape setting is wholly original. His knowledge of Jan Wijnants (c. 1630–84) may have given him the example of the framing tree, lit in textured patches, and the highlighting of the sandy landscape, but the whole has a sparkling immediacy, emphasised by the scale of the dog. It is the first of many occasions on which Gainsborough reacted to the individuality of the sitter to create in this instance, as Wootton only occasionally did, an animal conversation piece.

Similar effects of light can be found in a much more complicated setting in *Rest by the Way* (Philadelphia Museum of Art, Plate 3), a rare dated landscape of 1747. This is a large-scale landscape, though not quite so large as another early landscape which has also been dated *c.* 1747, now in São Paolo. Whereas that has been shown by Mary Woodall to be wholly based on a Ruisdael landscape in reverse, the Philadelphia landscape only hints at Wijnants and Ruisdael in the winding track, the undulating landscape, and carefully framed trees, unified by pools of light. The figure which gives the picture its title is not some elegant piece of *staffage* from the world of Gravelot, but a tattered peasant borrowed from Berchem. For all its Dutch antecedents, the total effect is of an English landscape illuminated by a fitful light from the swiftly scudding clouds. Gainsborough was just twenty.

Any attempt at a strict chronology of Gainsborough's early works is difficult. The evidence of the dated, or datable, landscapes and portraits is sometimes

contradictory, and he seems to have adopted various technical methods simultaneously. The landscape backgrounds of his portraits painted in Suffolk do not necessarily coincide with the way he painted in his landscapes, and recent technical examination of his early pictures conducted by Rica Jones, under the auspices of the Tate Gallery, has shown that his methods were experimental, and unlike any of his contemporaries. In other words, what we know of his later obsession with complicated procedures, notably from his letter to William Jackson (Plates 36, 37), seems to have begun early on. A set of four engravings after drawings by Gainsborough, 'Drawn after Nature', for example, were engraved and *published* in 1747 by the young John Boydell. These are spacious landscapes, drawn in layers, in an artificial Dutch manner, with small elegant figures dotted about in the manner of Gravelot. This must have been part of his style of *c.* 1746–7. His other early landscapes, though composed with the same interlocking planes, are much denser in texture, and the animals and figures are seen much closer to. His famous landscape of *Cornard Wood* or '*Gainsborough's Forest*' (National Gallery, London, Plate 4) is different again.

His obituarist in the *Morning Chronicle*, 8 August 1788, stated that 'the first master he studied was Wynants, whose thistles and dock leaves he frequently introduced into his early pictures. [This is evident in some of his early landscape drawings.] The next was Ruysdale, but his colouring is less sombre.' *Cornard Wood* combines both these influences and, as it has recently been suggested by H. Sasson, hints at a real track near Sudbury with a distant view of Great Cornard, but with the spire made smaller. It is a significant attempt by the young artist, who presumably still had high hopes of devoting his life to landscape, to incorporate his own direct observation from nature into a dense and significant work of art in the manner of Ruisdael. The problem of relating what he knew, and what he saw, to the finished product was not to be realised until his late works.

In 1748, he had been signally honoured by being included among those landscape artists who were invited to contribute a circular representation of a London charity hospital, in his case *Charterhouse* (Plate 5), to the decoration of the Court Room of the Foundling Hospital. For this topographical view he has drawn upon the urban landscapes of Jan van der Heyden (1637–1712). Gainsborough at the age of twenty-one was to be included in a list of leading British artists in 1748, so that it is surprising that he should have decided to leave London for Sudbury, where the opportunities for patronage would have been less obvious.

Very few of his early landscapes can be traced to a definite commission, even though the wooded landscape at Yale (see Plate 7) may have been connected with a local view. His friend Joshua Kirby (1716–74) owned a number of Gainsborough's early landscapes, which suggests that they were not sold immediately. The pious Kirby, incidentally, a topographer and painter in a small way, achieved greater fame as an expert on perspective which he taught at St Martin's Lane Academy. He edited Brooke Taylor's treatise on perspective, knew Hogarth well, and remained a close friend of Gainsborough who asked to be buried next to him at Kew. He may well have introduced Gainsborough's art to George III.

The only major commission which can be connected with Sudbury, that is of local sitters and painted when he lived there, is the portrait of *Mr and Mrs Robert Andrews* (Plate 8) whose family owned the substantial estate of Auberies outside Sudbury. It is an original and creative development of the conversation piece where his abilities as a landscapist and portrait painter were brought together in a manner which none of his contemporaries could achieve. His other Suffolk conversation pieces do not create such a sparkling fusion although landscape is always prominent, and there are no interiors. He may have travelled backwards and forwards to London, but, as he wrote to Jackson in 1767: 'Exeter is no more a place for Jackson than Sudbury in Suffolk is for a G.' In November 1751 he was negotiating a loan through James Unwin for £400, secured on his wife's annuity of £200 paid through the Duke of Beaufort. He was clearly hard up in Sudbury, and in 1752 he moved to Ipswich, where he also remained short of funds, borrowing money on a number of further occasions.

But at least he had access to a more convivial society. His early promise was now channelled, as he was to complain as late as 1783, 'to pick pockets in the portrait way'. He wrote to William Mayhew, a lawyer at Colchester, that he was 'afraid to put people off when they are in a mind to sit'. There were, for example, local politicians with estates, the Gravenor family (Plate 11), the Lloyds of Hintlesham Hall (Plates 9, 10), and John Plampin, of Chadacre Hall, near Lavenham outside Sudbury (Plate 12). His life-long friend and executor, Samuel Kilderbee (1725–1813) (Fine Arts Museum, San Francisco), was the Town Clerk of Ipswich, and together they visited the Lake District in 1783. Gainsborough's letters to him were considered 'too licentious to be published' and were destroyed, but it is clear that on this early gathering of Suffolk patrons and friends Gainsborough laid the basis of a convivial life of music and art that set the pattern of his life. There is a famous, now lost, picture of *The Music Club* at Ipswich, of which Gainsborough was a keen member.

His Ipswich portraits are all small head and shoulders or conversation pieces. A recently identified portrait of *Major Dade* (on loan to Yale Center for British Art from the Paul Mellon Collection) is a typical example of a sporting occasion commemorated in little. Gainsborough's sympathetic union of landscape and portraiture suited the middle class, but there was little opportunity for extensive landscape commissions. When he had the chance in 1755 to paint a landscape for the 4th Duke of Bedford, for the sum of 12 guineas (Plate 14), and its pair for 15 guineas, he was eager to throw off his conversation pieces and 'Dutch landskips' to paint a scene in the latest mode of French rustic courtship. It shows an awareness of Boucher and Fragonard, to which he has added his own sensitive observation of light and the shy interaction of figures. It remains as a high point of this period of English art.

His portraits of lesser aristocracy near Ispwich, such as *The Hon. Richard Savage Nassau* (Plates 16, 17) and the local MP, *William Wollaston* (Plate 18), also show that he was willing to expand his range, if the circumstances demanded it. A modern historian of the taste of the period, Iain Pears, has concluded that:

From the ideology of patronage and collecting to the philosophy of taste, it was the observer who was crucial for the development and importance of the arts, not the producer. No matter what social advances they made, painters consequently remained in the inevitably subservient position of creating works for others to taste.

This may well have been the case for Gainsborough's beginnings, but from his move to Bath from Ipswich, and subsequently to London, it is apparent that Gainsborough intended to impose his own taste on society, and on the forum for his art, the Society of Artists, and then the Royal Academy. The *Self-Portrait* drawing in the British Museum (Plate 13) is a conscious symbol of his newly found independence. The rest of his career shows how and with what difficulty he was able to impose his terms, and his later break with the Academy was to be about such an issue.

Even in Ipswich he could write, on 24 February 1757, to the lawyer, William Mayhew, at Colchester, whose portrait he had painted, about his expectations for viewing his paintings,

> I should be glad [if] you'd place your picture as far from the light as possible; observing to let the light fall from the left

and on 13 March 1758,

> You please me much by saying that no other fault is found in your picture than the roughness of the surface, for that part being of use in giving force to the effect at a proper distance, and what a judge of painting knows an original from a copy by; in short being the touch of the pencil [i.e. brush], which is harder to preserve than smoothness. I am much better pleas'd that they should spy out things of that kind, than to see an eye half an inch out of its place, or a nose out of drawing when viewed at a proper distance ...

Gainsborough, at this early stage of his career, was already well aware of the visual effects his pictures must achieve. To him the painterly touch, and how his portraits and landscapes were seen and lit, near to or far away, were to become obsessions in his art. The problem was still being debated at the famous Romantic Paris Salon of 1824, when Constable was pleased with the Comte de Forbin, the Director, for realising that his pictures needed to be seen near to and far away. What patrons dismissed as Constable's 'oatmeal' was a visual problem that Gainsborough had brought to the fore. He did not subscribe to a general ideal of balancing correctness of drawing, idealisation of forms and figures, and supremacy of the subject matter, which Neo-Classical art proposed, but attempted to achieve a personal revolution of expression from within the artistic system. The manipulation of visual effect rather than the tame delineation of poetic line was to be Gainsborough's concern. But he was not unaware of changes in taste.

His late Ipswich portraits of *William Wollaston* (Plate 18) and the *Hon. Richard Savage Nassau* (Plate 16) show him exploiting a visual rococo line with an awareness of the new changes in portraiture. During the 1740s and 1750s in

London, a larger-scale of portrait than Gainsborough had attempted became fashionable through the example of Hudson, his pupil Reynolds, his rival Ramsay, and the fashionable foreigners, Soldi and Van Loo. For the *Hon. Richard Savage Nassau*, who lived at Easton Park near Ipswich, he adapted the easy familiarity of his conversation pieces to a larger scale, with a more complicated composition, and the figure set in a grand interior. Wollaston is also shown inside, pausing whilst playing his flute. He was to paint the same sitter in his earliest full-length, set out-of-doors, in the fashionable 'cross-legged' pose.

This particular pose, ultimately deriving from a classical 'Pothos' figure, became the rage with all major and minor artists in England to express casual male elegance, as opposed to the formal stance found in contemporary books on etiquette, and Gainsborough was as guilty as any of his contemporaries in its over-use. He was rarely to exploit classical and Old Master prototypes, as Reynolds did so successfully, to ring the changes in full-length portraits. 'Damn him how various he is', Gainsborough was said to remark looking at Reynolds' portraits at the Royal Academy. Only at the end of his career did he achieve such variety (Plates 53, 70).

He was, however, to paint one individual masterpiece of portraiture at Ipswich for his own enjoyment, the magical image of his two *Daughters Chasing a Butterfly*, *c.* 1756 (National Gallery, London, Plate 15). Such a personal evocation of the fragility of childhood had no parallel except, perhaps, in the moving studies by Chardin during the eighteenth century, but it was indicative of the growing interest in children and their world, for which Gainsborough was a forerunner. Such images were not to find public expression in his art until he developed his more generalised 'fancy pictures' later on (Plates 56, 64). The painting was first probably given by the artist or sold to the Rev. Robert Hingeston (1698/9–1776), master of Ipswich Grammar School, a neighbour and friend of the artist, and then passed to his son, Rev. James Hingeston (1735–77), Vicar of Reydon with Southwold.

Gainsborough had almost run out of important clients in Ipswich, and, over the winter 1758–9, he toured the Midlands as an itinerant portrait painter, when he was praised for his 'exact likenesses', although his painting was considered 'coarse and slight'. By October 1759, his household effects in the house opposite the Shire Hall in Ipswich were advertised for sale, including some pictures and drawings at advantageous prices for his Ipswich friends. The painting of the 'Musical Club' was one such. The house was to be relet by the landlady, Mrs Elizabeth Wrasse, who had been the forbearing recipient of his letters for extra time to pay. He had decided, apparently hurriedly, to move to Bath. Thicknesse claimed that he had suggested the move, but Bath as a fashionable resort would have provided opportunities for portraits of its privileged clientele. The painter obviously, at this stage, did not feel like risking a full-time career in London, dominated in portraiture by Hogarth, Ramsay, and the rising Reynolds. Wilson, the landscapist, had also returned there after over six years in Italy.

Thicknesse helped him find quarters in the fashionable spa, first, apparently, in

the Abbey churchyard, and then Gainsborough may have moved to Ainslie's Belvedere. In 1763 he rented Lansdowne Lodge, Lansdowne Road, on the outskirts of the smart centre, and finally he moved to a house in The Circus, John Wood's elegant development. It is not known precisely in which house he lived, but the Duke of Bedford was a neighbour. Almost from the beginning he found that the number of visitors to Bath provided him with enough work.

If the history of British art is mainly the history of portraits of faces, houses, and animals, then Gainsborough, notwithstanding his constant complaints, was forced to adapt to this situation. During the winter season there was a constant stream of visitors of all classes to Bath, some to take the waters and others to cope with their needs, and Gainsborough, in spite of his wife's tight control of the accounts, was soon able to live a convivial, and eventually exhausted life, through overwork and over-indulgence in this lively city. He had only one principal rival, William Hoare (1707–92), whose work was conventional, but who could provide inexpensive, rapidly produced pastel portraits in the manner of Hudson. By October 1760, as Mrs Delaney's letter describing her visit to Gainsborough's studio reveals, where she saw his portrait of *Ann Ford, later Mrs Philip Thicknesse* (Plate 19), Gainsborough was on the fashionable round. The press of loungers must have been as irksome to him as the plethora of potential patrons. 'Damn Gentlemen, there is not such a set of Enemies to a real artist in the world as they are, if not kept at a proper distance ... ', as he wrote to Jackson in 1767.

He was cynically aware that a gentleman's purse was the only part worth looking at, and if they descended on him to chat and waste his time, his manservant was instructed to say his master was out. Only if they were interested in looking at his paintings were they to be admitted. If a handsome lady, on the other hand, arrived, then it was more than his servant's life was worth not to let her in!

He may have complained about his subservience to portraiture, unlike Reynolds who steadily stuck to his task, but he did not hesitate to provide what they wanted, but in his own terms if he could.

He did not contribute to the newly founded Society of Artists in 1760, but in 1761 he must have felt confident enough to send his works to London for public exhibition. He sent the full-length of *Robert Nugent*, later Earl Nugent, to the Society of Artists. He had already painted him the year before in three-quarter length – 'half-length' as it was then called, i.e. 50×40 in. – for Bristol Corporation, where Nugent was the MP. Nugent, however, had an estate at Gosfield Hall between Braintree and Halstead in Essex, and local connections may have helped Gainsborough to get started. For the full-length of Nugent and for some other early Bath portraits Gainsborough showed the sitter lit from the left by a window. The fall of light was a constant preoccupation of his.

The Society of Artists in London provided an opportunity for provincial artists to enlarge their clientele and, for Gainsborough, the range of his portraiture. Now in direct competition with the London-based artists, such as Hudson and Reynolds, he was to send a series of full-lengths to make his mark. *William Poyntz*

(Plate 21) was exhibited in 1762, and is also a full-length, but set out-of-doors. It re-creates his small Suffolk portraits of gentry and sportsmen at ease on a larger, more impressive scale, which he had already begun with the full-length of *William Wollaston* (Plate 18). He was to send fourteen full-lengths to the Society of Artists in Spring Gardens during the 1760s, and there were many more that were not publicly exhibited, including the ravishing *Mary, Countess Howe* of c. 1763–4 (Kenwood, Plate 26), and he was to continue to develop this range of portraiture on a large scale at the Royal Academy, of which he was a Founder Member. This impressive series of more than four dozen full-lengths on the scale of life between 1760–72 provided him with public prominence, so that he was able to raise his prices from 8 guineas for a head to 20 guineas, 40 for a half-length, and 80 guineas for a whole-length. Between 1770 and 1772 he raised them again to 30, 60, and 100 guineas, respectively, not to be changed until 1787, when he raised them finally to 40, 80, and 160 guineas. Reynolds, meanwhile, was charging, during the period 1764–77, 35, 70 and 150 guineas for the same sizes, to be raised again in 1782 to 50, 100, and 200.

Gainsborough was also to paint charming half-lengths at the outset of his career in Bath, such as the attractive portrait of *Sarah Hodges, later Lady Innes* (Frick Collection, New York), who was, as John Bensusan-Butt has realised, a local Ipswich girl. She did not become Lady Innes until 1768. *Mary Little, later Lady Carr* (Plate 23) has recently re-emerged as an exquisite display of the painterly techniques which he developed when he arrived in Bath.

Bath was situated within reach of country-house collections, for example Lord Methuen's, the nearest, at Corsham Court, the Earl of Pembroke's at Wilton House, the Earl of Radnor's at Longford Castle, Lord Bateman's at Shobdon Court, Earl Harcourt's at Nuneham Park, which Gainsborough had already visited before his move to Bath. The Duke of Montagu's collection at Boughton House, Northants, and in London which he had recommended to Garrick in a letter of 1768 for *The Watering Place* by Rubens and for four Van Dyck whole-lengths 'in his Grace's dressing room', also provided Gainsborough with examples of portraiture on a grand scale which he had little opportunity of seeing in Suffolk.

The outstanding influence was that of Van Dyck, whom Gainsborough fully realised at the end of his life was of the party when they all went to Heaven. Van Dyck provided a lesson for any budding portraitist in how sitters could be flattered by elegance, and sensitivity of pose and touch. Gainsborough's contemporaries in the business of face painting were to be influenced by Van Dyck's subtlety: Hudson, Ramsay, Reynolds, Cotes, and Romney in various ways all attempted to emulate his example. Above all, however, Gainsborough, who never went abroad, learned through Van Dyck's paintings how to enlarge and improve his own art. Van Dyck flattered his sitters with elongated poses, and by moving them easily but elegantly through the space of the canvas. To these stylistic manœuvres, Gainsborough could add an equal sensitivity to the sitter, a similar refinement of drawing, and his own subtlety of colour and handling.

Mrs Thicknesse (Plate 19) was a first, if slightly over-exuberant, attempt to come to terms with this grander style of portraiture. Drawings such as *A Woman with a Rose* (Plate 24) and a *Woman Seen from Behind* (Plate 25) show him experimenting with this new-found knowledge which culminated in his early masterpiece of *Mary, Countess Howe* (Plate 26). By the time he painted the *Duchess of Montagu* (Plate 33), *c.* 1768, the lessons had been learned, and his portrait of *Jonathan Buttall, 'The Blue Boy'*, *c.* 1770 (Plate 35), is almost a parody of the excesses of Van Dyck's style.

He copied Van Dyck, or borrowed poses from him, throughout his life, more than from any other artist. There is a copy of Van Dyck's *Pembroke Family*, in the collection of the Marquess of Northampton, which was said to be 'Painted by Memory, after having seen the original at Wilton'. There is an impressive full-length double portrait in the St Louis Art Museum after Van Dyck's *Lord John and Lord Bernard Stewart*, now in the National Gallery, London, perhaps the epitome of cavalier elegance. As late as 1785, he copied the equestrian portrait of the *Duc d'Arenberg* at Holkham with a view to painting a companion of the Prince of Wales.

He was not able, as Reynolds was, to exploit the whole range of Van Dyck's poses, but to those he used he also sometimes added an earthy quality of his own. This reminds us of his early association with Hogarth, in such plain-speaking portraits as *Sir Benjamin Truman*, *c.* 1770–4 (Plate 39), or *Sir William Johnstone-Pulteney*, *c.* 1772 (Plate 40). Equally, his late Romantic portraits of *The Hon. Mrs Thomas Graham*, 1777 (Plate 46), and *Grace Dalrymple, Mrs John Elliott* (Plate 47) show how well he had assimilated Van Dyck into his own imaginative creations. The public exhibition of his full-lengths, beginning from his period in Bath, enabled him to develop completely a style of portraiture which eventually became his own, but of all the portraitists from whom he learned, for example Rubens, Rembrandt, Titian, and Lely, it was to Van Dyck that he was the most sympathetic.

Gainsborough's stay in Bath provided so many sitters that he exhibited few landscapes, although some were sold directly from his studio. He did not stop drawing or painting landscape, and it remained an essential part of his own personal approach to art. As with his portraiture, he tried hard not to compromise, as demonstrated by his frank letter to the Earl of Hardwicke of *c.* 1762–3:

> Mr Gainsborough presents his Humble respects to Lord Hardwicke and shall always think it an honor to be employ'd in anything for his Lordship; but with respect to *real Views* from Nature in this country he has never seen any Place that affords a Subject equally to the poorest imitations of Gaspar or Claude. Paul Sanby [sic] is the only Man of Genius, he believes, who has employ'd his Pencil that way – Mr. G. hopes Lord Hardwicke will not mistake his meaning, but if his Lordship wishes to have anything tolerable of the name of G, the subject altogether, as well as figures etc. must be of his own Brain; otherwise Lord Hardwicke will only pay for Encouraging a Man out of his way and had much better buy a picture of some of the good Old Masters.

This is an astonishing letter for an artist to write who was making his way in his profession (Gainsborough was thirty-seven), although he was to paint a portrait of Lord Hardwicke's eldest son, Lord Royston, in 1763. The insistence, however, on his own imagining did not preclude occasional views of a real place, and he was to paint King's Bromley, Staffs. for the owner (Plate 34), *c.* 1768, although this can hardly be called a conventional topographical view. He also based a number of his imaginary landscapes on details he had observed in nature (for another example see under Plate 20, of 1760).

This drawing was made on an early excursion to Foxley, Herefordshire, to the Price family with whom he had quickly become acquainted. He painted the portrait of Uvedale Tomkyns Price (1685–1764) (Munich) and his son, Sir Robert Price, but he had also become friendly with the grandson, Uvedale, who accompanied the artist on his walks around Foxley. Price's later theories in his *Essay on the Picturesque* (1794–8) may well have originated, in part, from his conversations with the artists. From the drawing he made on the spot at Foxley, he produced a finished painting for his Ipswich friend, Samuel Kilderbee.

Even if Gainsborough only exhibited four landscapes during the 1760s they were impressive enough, and, as with his portraiture, they were influenced by what he could see in collections not too far from Bath. The large landscape at Worcester, Mass., probably exhibited at the Society of Artists in 1763, and *The Harvest Waggon*, Birmingham, Society of Artists 1767 (Plate 29), are significant examples of his development. Though the public at large were probably unaware of his range, Thomas Jones in his *Memoirs* could write that when he began in London, *c.* 1765, 'there was Lambert, & Wilson, & Zuccarelli, & Gainsborough, & Barret, & Richards & Marlow in full possession of Landscape business'. By *c.* 1767–8 Gainsborough was commissioned as one of a group of three probably consisting of Wilson, Barrett, and Gainsborough by William, Lord Shelburne, later 1st Marquess of Lansdowne 'with a particular injunction that each artist should exert himself to produce his *chef d'œuvre* as they were intended to lay the *foundation of a school of British landscapes*'. Gainsborough's work was *Peasants Returning from Market through a Wood*, Toledo (Plate 32), and it hung with the others in the drawing-room at Bowood.

Gainsborough drew selectively on a number of seventeenth-century landscape artists to give his own landscapes an impetus towards a grand style. Above all, the knowledge of Rubens, and to a lesser extent his follower Lucas van Uden, put him in the way of expressing great distances and massed compositions combined with detailed natural observation, as they were to do with Constable. Claude and Cuyp provided a mastery of the unifying effects of light from which he could learn, as could the Italianate Dutch artists Jan Both and Berchem, who also used individual figures as *staffage* with telling effect. When John Smith later described a Jan Both, with returning travellers and one beside a track, as containing 'the richest hues of a refulgent sunset', he could have been describing Gainsborough's *The Harvest Waggon* (Plate 29), *Peasants Returning from Market through a Wood*, Toledo (Plate 32), or the *Peasants Going to Market*, Royal Holloway College (Plate 41).

These are but three of a series with a similar theme in which he put his experience of majestic landscape paintings he had seen around Bath.

Selling landscapes was more difficult than portraits but he did achieve private sales. His large size of landscape, approximately 48×58 in. horizontal or vertical, fetched 40 guineas in 1766 (to Sir William St Quentin), while he sold the luminous *Peasants Going to Market* (Plate 41), of an equivalent size, to his banker, Henry Hoare at Stourhead, for 80 guineas in 1773, almost as much as he received for a full-length portrait at that date. *The Harvest Waggon* (Plate 29) of 1767 was given in 1774 to his carter and packer, Walter Wiltshire of Shockerwick Park, later mayor of Bath, for services rendered in transporting his works. It is clear that during the 1760s and 1770s there were exceptional patrons with *taste*, as Gainsborough would have described them, who were willing to buy his imaginative landscapes, but, on the whole, the more conventional landscapes of Zuccarelli and imitations of Claude were preferred.

His imaginative landscapes were not only a re-creation of the Old Masters he had seen. He is reported to have sketched assiduously out-of-doors, and nature was repeatedly claimed as his first interest. The countryside around Bath provided far more dramatic aspects of landscape than the placid Suffolk countryside he had been used to, and both the young Uvedale Price and Osias Humphry report that they accompanied him on sketching excursions into the country. In 1782 he was to go on a tour of the West of England with his nephew, Gainsborough Dupont, and the following year he made a tour of the increasingly fashionable Lake District with his Suffolk friend, Samuel Kilderbee.

We know, however, that he also sketched indoors of an evening as a form of relaxation, and although there are wonderful glimpses of things seen that seem to have remained in his memory, such as *Beech Trees at Foxley* (Plate 20), the casual indolence of the boy in a cart (Plate 31), and the flash of light across the track in the *Wooded Landscape* (Plate 30), the surrounding landscape backgrounds seem less closely observed. The studies of a cat on a single sheet at Amsterdam is a rare instance of Gainsborough's quick eye and rapid manipulation of chalk on the spot, but there are few other pages extant from sketchbooks, except from very early in his career, which we would expect from his sketching. There are, however, drawings such as *A Woodland Pool with Rocks and Plants* (Plate 28) which have the appearance of close observation, but which were more probably translated from the 'roots, stones, and mosses' which he laid out on a small table to provide material for his foregrounds and which, indeed, provided the basis for entire compositions. His landscape drawings, and consequently his major finished landscapes during the Bath period and beyond, were, as contemporaries realised, created from his own genius. They are a sort of musical improvisation about the idea of landscape.

But is this entirely what his landscapes are about, given that few were commissioned directly? It has been recently suggested that these obviously private creations, one of which Gainsborough proffered to Lord Shelburne as his *chef d'œuvre* for 'the foundation of a school of British landscapes', cannot be

described in general terms as 'musical', or merely 'rustic-pastoral', or 'poetic', though these terms were used in the eighteenth and nineteenth centuries to describe works of feeling. It has also been suggested, notwithstanding his friend Jackson's comment that Gainsborough scarcely read works of literature and was not a literary buff, that his imaginative landscapes can be directly linked to a specific literary idea, that of a country retirement from the world, promulgated through the writings of the Rev. Richard Graves (1715–1804) and his friend William Shenstone (1714–63).

It is true that the Rev. Richard Graves was an early admirer of Gainsborough's work in Bath, and had praised it in a poem published in 1762, later re-published in Shenstone's *Miscellany*. Graves lived at Claverton, near Bath, and Ralph Allan, the landscape gardener, was a neighbour at Prior Park. Their friend was William Shenstone, most famous for his retirement from the world at Leasowes near Halesowen, on the border of Worcestershire and Staffordshire, where he had created a landscape garden. None of them would have been unknown to Gainsborough. Graves' poem was entitled 'On Gainsborough's Landskips with Portraits; full length Figures less than Life, drawn in Pairs as walking thro' Woods etc ... ' His title is a fair description of Gainsborough's early style, and the poem goes on to describe the aim of poetry and painting 'to charm the soul' and compares 'that blest pair', presumably a mortal pair in a portrait, with Adam and Eve, who have lost their Paradise, but the 'pleasing cheat' is 'so well sustained,/Each Landskip seems a Paradise regain'd'. Much has been made of this, that Gainsborough's landscapes and his portraits interact to 'constitute an art of retirement that involves the serious contemplation of man in a fallen state'.

This may well be a serious underestimation of Gainsborough's subtlety and personal view. He could be pious to his sister in Bath, but, as Farington later remarked, he 'talked bawdy to the King and morality to the Prince of Wales'. In other words, we should not restrict Gainsborough to a comparison which Graves made in the way of flattery. Graves, after all, in his *Euphrosyne* equally praised Copplestone Warre Bampfylde (1720–91), a country gentleman and an amateur draughtsman from Somerset:

> In B—mpf—d's pencil we delighted trace
> Salvator's wildness but with heightened grace

which does not say much for Graves' critical faculties as regards painting.

The Rev. Samuel Bishop's poem on *Landscape Painting* could equally well describe a landscape by Gainsborough:

> Let next in order due succeed
> The mingled hues of vale and mead;
> The road in devious windings wrought,
> Now lost, and now at distance caught;
> Whose broken track directs us still
> To some brisk streamlet's glassy rill ...

Richard Graves could be sharp and funny, which is more than can be said for Bishop, but though both evince some appreciation of painting and landscape, their writing is banal compared to the depths of expression and subtlety of handling in Gainsborough's art.

Gainsborough's Bath and London landscapes have also been unfavourably contrasted with the real plight of the rural poor, which they do not seem to acknowledge. His contemporaries all commented on his natural tenderness towards hardship, and his sympathy for a simple country life. He was later (1783) to joke to the architect Sir William Chambers, RA (1723–96) that he intended 'to turn into a cot & turn a serious fellow', rather as Shenstone had, but he never did, nor can we imagine him ever doing so. He was, undoubtedly, a man of feeling in Rousseauesque terms, but although he was generous in his charity to the poor – his letter to Chambers is actually to solicit work for an out-of-work Scottish carpenter – his representations of the poor were expressed in general Arcadian terms, as it was then understood.

His experiments in mixed media begun in Bath which reworked old images of landscape in a new way (Plates 36, 37) were, perhaps, closest to his real aims of extending the range of expression, of blurring the distinction between a sketch and a finished picture. Apart from his mixtures of chalk and varnish, Henry Angelo records his using sugar tongs from *c.* 1768 to grip sponges, dipped in 'warm and cold tints', already prepared in saucers, to prepare the 'masses' and 'general effects', which were then touched up in 'black, red, and white chalks'. In this respect he can be considered as a Romantic artist before his time.

He left Bath in 1774 as hurriedly as he had left Ipswich. A Broadwood harpsichord was due to be delivered to him, a reminder of his social and musical life which the drawing of *A Music Party* (Plate 38) records, but he left before it arrived. Thicknesse claimed his departure was due to a misunderstanding about a portrait of himself, a later pair to that of his wife (Plate 19), and a gift of a viol da gamba which Gainsborough returned. The real reason may have been the drying up of portrait commissions in Bath, of which Gainsborough had become the principal ornament, as Joseph Wright of Derby was to complain when he went there in 1775, and, perhaps, more important, the necessity of being in London to look after his interests at the Royal Academy, and establish a firm base at the centre of art.

His fame was such that he had been invited to become a Founder Member of the Academy in 1768, which caused his withdrawal from the Society of Artists. His old friend Joshua Kirby (1716–74) was left running an organisation from which all the leading artists had moved to a more prestigious society under royal patronage. Gainsborough had been an exhibitor at the first exhibition of 1769, with two impressive portraits of the *Countess of Sefton* (Liverpool) and *Lord Rivers*, and a landscape, and was to show there regularly with portraits, including one of his friend Jackson in 1770, and landscapes, including ten of his experimental drawings 'in imitation of oil painting' in 1772.

His relations with the Academy were not smooth. Even before his departure from Bath he had quarrelled in 1773 because, as he complained to Garrick, they

hung his 'likenesses too high to be seen, & have refused to lower one sail to oblige me . . . '. He did not exhibit there from 1773 to 1777, which may have been why his early years in London were described as not very profitable. He did not attend Council meetings, although he did vote, and expected preferential treatment for the way his pictures were hung. A similar row erupted in 1784 and after this he was not to exhibit at the Academy again. He was to organise exhibitions of his own work at Schomberg House. This shows some independence from an organisation that had become the only place to be seen.

His Christmas letter of 1775 to his Methodist sister, Mary Gibbon, at Bath, revealed some disquiet about his expenses, his future, and his family:

> What will become of me time must show; I can only say that my present situation with regard to encouragement is all that heart can wish, but as all worldly success is precarious I don't build happiness, or the expectation of it, upon present appearances. I have built upon sandy foundations all my life long. All I know is that I live at a full thousand pounds a year expense, and will work hard and do my best to go through withal . . .

He went on to discuss his disquiet about his marriage and daughters:

> If I tell you my wife is weak but good, and never much formed to humour my Happiness, what can you do to alter her? If I complain that Peggy [his youngest daughter Margaret] is a sensible good Girl, but Insolent and proud in her behaviour to me at times, can you make your arm long enough to box her ears for me whilst you live at Bath?

He was also to complain about his younger daughter Mary's liaison with Fischer, the oboist (Plates 15, 50). He was rather a stern father and husband, in spite of his own irresponsible behaviour, and he knew well how his wife had to control the purse strings.

On his arrival in London, probably towards the end of 1774, he had taken a tenancy of the west wing of Schomberg House, Pall Mall, the façade of which still stands. This was named after the Dukes of Schomberg, but was owned by John Astley, an artist who had married a rich widow. Another part of it was let to the notorious Dr Graham, whose Temple of Health showed nude spectacles of the Goddess of Health on the Celestial Bed. Apart from these passing distractions which may have been of some interest to the artist, Christie's auction rooms were then next door to the east, where we know Gainsborough did spend a good deal of his time. The auctioneer, James Christie (*c.* 1730–1803), was painted by Gainsborough in 1778 in an inimitable mode of expecting a bid, and it now, perhaps fittingly, belongs to the J. Paul Getty Museum, Malibu, California. Gainsborough's presence at auctions with his cronies was thought to add at least 15 per cent to Christie's commissions.

Nevertheless, Gainsborough's first London works were mostly of a small size, and not much of a development from his Bath portraits. He had, however, already become enamoured of the visual effect of transparencies which influenced his art for the rest of his career. He was much involved with the decoration of a new

concert room which was opened in Hanover Square in February 1775 by J. C. Bach, whose portrait he was to paint in 1776, and C. F. Abel, whose portrait he painted in 1777 (Plate 45). 'A Comic Muse' by Gainsborough was 'most spoken of', 'lighted from behind', and painted on glass.

This was to lead to his fascination with peepshows and lighted spectacles of every sort of which his friend de Loutherbourg's *Eidophusikon*, first displayed in February 1781, was the best known and most impressive (Plate 48). Gainsborough's transparencies were developed on a smaller scale from his *Comic Muse* for his own lightbox (Plate 55), but his interest in the effects of light were to influence all of his subsequent work.

His painting rooms were not lit by a conventional north light. He painted with blinds drawn, or by candlelight, and he did not like painting a portrait without being in front of the sitter. Any artist as susceptible to the evanescent effects of light as Gainsborough faced the difficulty of rendering in opaque pigments and translucent glazes that which was almost inexpressible, and which even the invention of the camera did not resolve.

Against this had to be reconciled the difficulty of subtle effects being lost on the crowded walls of the Royal Academy, unless the paintings were large and boldly painted. As Gainsborough wrote to Garrick:

> A Word to the Wise; if you let your Portrait hang up so high, only consult your Room, and to insinnuate something over the other Door, it never can look without a hardness of Countenance and the Painting flat, it was calculated for breast high and will never have its Effect or likeness otherwise.

The idea of lighting transparencies from behind was to make him even more aware of the liquidity of his paint which could create an inner, flickering light so that his portraits and landscapes could express likeness and *chiaroscuro*. His late Bath landscapes, and one painted perhaps in London, *A Rocky Valley*, at Yale (Plate 43), have, in addition to their debt to Old Masters, in this case Gaspard Dughet and Salvator Rosa, an inner light achieved by glazes and tonal manipulation which carries strongly when viewed from afar. *The Watering Place* of 1777 (National Gallery, London) (Plate 44) and the *Wooded Landscape* of 1782, now at Sudbury (Plate 55), are further sophisticated examples of how transparencies influenced his art.

The practical difficulties of experimenting for, and executing, his *Comic Muse*, and its subsequent installation in the concert room between late autumn 1774 and February 1775, plus simultaneously setting up a new studio and house in a shambling building, may well have caused delays to producing commissioned portraits. He may not have felt ready or able to exhibit anything substantial at the Royal Academy until 1777, but he reappeared in great style with major full-length portraits and a landscape, which Horace Walpole described as 'by far the finest landscape ever painted in England, equal to the great masters'.

This was *The Watering Place* (Plate 44), and its connection with his experimental light effects has already been mentioned. Its debts to Rubens and the tradition

25

of Old Masters are equally obvious. Nevertheless, the impressive landscapes, produced in the last decade of his life in London, did not, on the whole, sell well. Beechey later commented that his landscapes 'stood ranged in long lines from his hall to his painting-room, and they who came to sit for him for their portraits, for which he was chiefly employed, rarely deigned to honor them with a look as they passed them'. *The Watering Place* was one of a number which remained unsold.

More important for the moment, however, was the change in his career brought about by the patronage of the Royal Family. He exhibited full-lengths of the Duke and Duchess of Cumberland at the Academy of 1777, which he must have been working on during the previous year, and he was to paint the couple again in his sly, yet magical group portrait of *c.* 1783–5 (Plate 60). By 1781 his fame was 'quite established at Buckingham House', so that he was 'the Apollo of the Palace'.

He may have been first recommended to George III by Joshua Kirby who taught the King perspective. Reynolds was President of the Royal Academy, yet Gainsborough's direct attitude and personable character may have won the King over, in contrast to the stuffiness which they detected in Reynolds. According to Northcote, Gainsborough was a 'natural gentleman', and, in spite of his disso-luteness, he could talk 'bawdy to the King, and morality to the Prince of Wales', as Gainsborough admitted to Desanfans (reported by Farington). Artistically, his concern with likeness and antipathy to 'fancy dress' may equally well have appealed to the royal taste. This partiality undoubtedly contributed to the rivalry between Gainsborough and Reynolds, who was, nevertheless, appointed Painter to the King on the death of Ramsay in 1784. This was a purely nominal position, as the Royal Family obviously preferred Gainsborough's portraits of the King and Queen, exhibited at the Academy in 1781. Equally, Gainsborough was 'rivetted' by the Van Dycks he saw at Windsor, and at Buckingham House.

His portrait of *Queen Charlotte*, exhibited in 1781, was acknowledged by many, even by Reynolds' pupil Northcote, as a consummate and 'picturesque' piece of flattery of a plain woman:

> 'Tis actual motion, and done with such a light, airy facility. It delighted me when I saw it. The drapery was done in one night by Gainsborough and his nephew; they sat up all night, and painted it by candle-light. This in my opinion, constitutes the essence of genius, the making beautiful things from unlikely subjects ...

Queen Charlotte was to own twenty-two of Gainsborough's drawings, including ten of his coloured drawings, but twenty were sold in her sale of 1819.

His royal success led to a group full-length of *Princess Charlotte with her Two Sisters* (HM The Queen), unfortunately cut down in the nineteenth century, and fifteen small portraits in oval, which were the occasion of his final break with the Academy in 1784. He had threatened to withdraw if his pictures were shown higher than 'five feet and one half', and he had written a direct note to the secretary, P. A. Newton, about his small portraits:

26

I wd. beg to have them hung with the frames touching each other, in this order. The names are written behind each Picture – God bless you. hang my Dogs & my Landskips in the Great Room. The Sea Piece you may fill the small room with – Yrs. sincerely in haste –

T. Gainsborough

He drew a diagram of how these fifteen small rectangles were to be hung in three rows of five, edge to edge, but the Academy of fellow artists was not to be dictated to, and Gainsborough withdrew everything, never to exhibit there again, although he kept in touch with Academy affairs and remained an Academician. His royal patronage was to extend to the Prince of Wales, the most profligate and, since Charles I, the most sensitive of royal collectors (Plates 47, 50, 52, 60, 61, 62).

His success had stemmed from his reappearance in 1777, but at the Academy in addition to the royal patronage, so important for a fashionable portraitist, he had gained a public champion in the person of Henry Bate (Plate 49), later Sir Henry Bate-Dudley. He was to become Gainsborough's principal champion, first in the *Morning Post*, and then, from 1780, in the *Morning Herald*. His first sympathetic account is of the 1777 Academy exhibition when he favourably noticed *The Watering Place* (Plate 44), but pointed out that it was hung very disadvantageously, the first of many such comments that he clearly received from the artist himself. They were to become close friends, and Gainsborough seems to have had a country cottage on his estate in Essex.

He had made an equally spectacular return to the Royal Academy of 1777 with his full-length portraits. Those of the Duke and Duchess of Cumberland have already been mentioned, but *The Hon. Mrs Thomas Graham* (Edinburgh) (Plate 46) and *Carl Friedrich Abel* (San Marino) (Plate 45) are equally splendid. From now on, his large portraits, although never without a likeness, become highly personal images, where the sitter, the costume, and the background are united by bravura handling. *Grace Dalrymple, Mrs John Elliott* of 1778 (New York) (Plate 47), *Johann Christian Fischer* of 1780 (HM The Queen) (Plate 50), *Mrs Mary Robinson, 'Perdita'* of 1781 (Wallace Collection) (Plate 52), and *Giovanna Baccelli* of 1782 (Tate Gallery) (Plate 53), are impressive examples of his creative progress, which in its own personal way rivals the dramatic and more generalised variety of Reynolds' portraiture. Bate enthused at the Academy Exhibition of 1782 'That this celebrated artist has soared with genius to the highest regions of taste and may now content himself with a professional fame that few will ever arrive at, none excel!'

Reynolds' supporters did not agree, but Gainsborough's famous portrait of *Mr and Mrs William Hallett* of 1785 (National Gallery, London) (Plate 66) is known best by its generalised title of *The Morning Walk*, and it has become the embodiment of an age, with the sitters' names almost forgotten through their subservience to the overall painterly qualities.

These examples give the impression that his portraiture was best suited to a particular class of sitter, men of taste and elegance, such as the *Prince of Wales*,

1782, or *Col. St Leger*, 1782, or sensitive portraits of artists and musicians, such as *Philip James de Loutherbourg*, 1778 (Plate 48), or *Johann Christian Fischer*, 1780 (Plate 50), or, most typically, ethereal portraits of beautiful women, some representatives of the *demi-monde*, such as *Mrs Elliott*, 1778 (Plate 47). A French visitor to London, incidentally, thought it was scandalous that these should hang alongside respectable aristocratic portraits. His range has, accordingly, been criticised as being inferior to that of Reynolds, whose portraits of Whig politicians and old men of character were most notable during the 1780s. This is not entirely the case. Gainsborough did paint shrewd portraits of men of substance, and character, such as the *Hon. William Fitzwilliam*, 1775 (Fitzwilliam Museum, Cambridge), *John Wilkinson*, the iron-master, mid 1770s, now at Berlin, *Viscount Gage*, RA 1777, the *Duke of Northumberland*, RA 1783 (Middlesex Guildhall), and *Admiral, Lord Rodney*, 1783–6, where he appears to be striving to emulate Reynolds.

Nevertheless, his late portraiture will be remembered for *Mrs Richard Brinsley Sheridan*, 1785–6 (National Gallery, Washington, D.C.) (Plate 67), rather than these sturdier examples, partly because the main thrust of his art towards the end of his life had taken a more romantic turn, of which his portraits can be seen as one aspect. His personal development of the 'fancy picture' was to incorporate elements from his portraiture, his landscapes, and his own sensitivity to the human predicament.

His extension of this new class of picture – and Reynolds was also to produce examples – evoked and exploited a particular contemporary feeling, and is another instance of Gainsborough's awareness of contemporary taste. He had made, as it were, portraits on the scale of life, of poor boys and girls, and had drawn on the example of a recently rediscovered artist, Murillo, whom Gainsborough had copied for his purposes. But whereas Murillo's scenes of low life with beggar children are earthy and direct, Gainsborough's are wistful and melancholy. They have no explicit moral tale to tell, as with the French examples of Greuze, neither are they realistic descriptions of the lot of the poor. They merely ask us to sympathise with poverty, and give us some glimpse, however distant, that poor children have feelings. His ability to externalise the finer emotions of children could be compared, in general eighteenth-century terms, with the ideas of virtuous innocence and contentment, promulgated by Jean-Jacques Rousseau (1712–78), whose *Emile* (1762), for example, advocated natural surroundings and individual freedom for a child's upbringing. Gainsborough's images look forward to the operatic expression of individual emotion which the Romantic movement brought about, but his voice is quieter, his stance more elusive, and, to our modern eyes, perhaps sentimental.

His *Girl with Pigs* (Plate 56) was the most popular picture at the Academy of 1782, and was bought by Reynolds. A similar girl appears in the *Girl with a Pitcher* of 1785 (Plate 64). A contemporary description admired its charming landscape, 'with sheep and pastoral objects', but Hazlitt later thought its 'sentimental pensiveness' insipid and vacant, and that it had an 'unvaried smoothness to

which real nature is a stranger, and which is only an idea existing in the painter's mind'.

It might be added that all of Gainsborough's late works existed only in his mind. Although he exhibited landscapes based on a trip to the Lake District in 1783 with his old friend Samuel Kilderbee, none could be said to be exact topographical representations of the Lakes. His seascapes (Plates 54, 59), which he first introduced at the Academy of 1781 and which were praised for their 'pellucid pencilling of the water and the etherial clearness of the sky', owe as much to general memories of the sea, and sea painters, and his experiments with cool and warm light in his transparencies. His cottage scenes are, equally, developments of his earlier peasant scenes with the figures concentrated around a cottage door. The Huntington version of 1780 (Plate 51) is the most famous, according to a contemporary critic re-creating 'Adam's Paradise', but the evening scene at Sudbury of 1782 (Plate 55) carries the idea farther, with a monumentality of composition and subtlety of evening light effects, to which his transparencies also contributed. His attempt to create his own personal History style out of subjects that in themselves were not heroic, based on landscape, which was not high in the artistic hierarchy of styles, and drawing on an eclectic range of old and modern masters, major and minor, from Titian and Rubens to Watteau, Ruisdael, Boucher, and Vernet, from Salvator Rosa, Claude, Gaspard Dughet, and Snyders to the *Eidophusikon*, provided a mix that was beyond the range of contemporary decorum in art, as he was clearly well aware. His letter to Sir William Chambers of 1783 – after Reynolds the most powerful figure in the Academy – expressed his aims indirectly, in his inimitable allusive way:

> ... I sent my fighting dogs to divert you. I believe next exhibition I shall make the boys fighting & the dogs looking on – you know my cunning way of avoiding great subjects in painting & of concealing my ignorance by a flash in the pan. If I can do this while I pick pockets in the portrait way two or three years longer I intend to turn into a cot & turn into a serious fellow; but for the present I must affect a little madness. I know you think me right as a whole, & can look down upon Cock Sparrows as a great man ought to do, with compassion ...

He often introduced a jokey tone when he was being most serious. He had always been basically a serious fellow, but he had no intention of permanently diving into a cottage, an obvious jibe at Shenstone's retirement from the world, though he could retire to his house at Richmond for relaxation in his later years.

With such works as the *Mountain Landscape* at Washington, *c.* 1784 (Plate 61), his unfinished *Diana and Actaeon* of *c.* 1785 (Plate 62), his lost *Woodman* of 1787, of which he was most proud, unfortunately burnt in 1810, his *Market Cart* of 1786 (Plate 68), and *Peasant Smoking at a Cottage Door* of 1788 (Plate 75), his aims of unifying his style and subject matter were realised. *Diana and Actaeon* (Plates 62, 63) was his only figure composition of a mythological scene, apart from the single nude figure called *Musidora* (Tate Gallery) (see discussion of Plate 63), and at first *Diana and Actaeon* appears to be equally a figment of his own personal

imagination, however fragmentary and rococo in spirit. It does, however, contain subtle, indirect references to a variety of figures taken from Old Masters, for example, Titian, Albani, and Watteau, and even Hellenistic sculpture, at second hand, which shows that Gainsborough was more of a serious fellow than he sometimes let on.

In May 1788, during his final illness, he wrote to the collector, Thomas Harvey, at Catton, near Norwich, who had bought his *Cottage Door* (Plate 51) among others of his works:

> God only knows what is for me, but hope is the Pallat Colors we all paint with in sickness – 'tis odd how all the Childish passions hang about me in sickness, I feel such a fondness for my first imitations of little Dutch Landskips that I can't keep from working an hour or two of a Day, though with a great mixture of bodily Pain – I am so childish that I could make a Kite, catch Gold Finches, or build little Ships ...

His art, however, was a much more sophisticated rendering of his early interests. He had transformed his rococo style into a private romantic world.

This world was almost entirely visual. There are analogies with music, in that from the fixed modes of portraiture, or pastoral scenes in a general Arcadian mood – which he actually developed in his own terms – he improvised a series of variations, whose transitions were instinctive and emotional. In his art, there were oblique general references to eighteenth-century literature, but there is nothing very specific or coherent. There is no doubt, however, that his expression is on a higher emotional plane than the poetry of the Rev. Richard Graves, or William Shenstone, with whom he has been linked. This relative indifference is to be expected from someone who, according to the serious recollection of his close friend Jackson, 'avoided the company of literary men, who were his aversion' and 'scarcely ever read a book'.

The most sensitive appreciations of his intensely visual art were those of Reynolds and Constable, who were best able to conjure up the visual memories to which his paintings and drawings so often refer.

A few days before his death, Gainsborough wrote a touching note which Reynolds reported:

> The extreme affection which I am informed of by a Friend which Sir Joshua has expresd induces me to beg a last favor, which is to come once under my Roof & look at my things, my woodman you never saw ... I can from a sincere Heart say that I always admired & sincerely loved Sir Joshua Reynolds ...

Reynolds went on:

> If any little jealousies had subsisted between us, they were forgotten, in those moments of sincerity; & he turned towards me as one, who was engrossed by the same pursuits ... without entering into a detail of what passed at this last interview [typical of Reynolds' reserve] the impression of it upon my mind was, at his regret at losing life, was principally the regret of leaving his art; and

more especially, as he now began, he said, to see what his deficiencies were; which he said, he flattered himself in his last works were in some measure supplied.

Reynolds' moving tribute in his 14th Discourse, in which he recounts his last meeting with Gainsborough on his deathbed, confirms that Gainsborough felt that he was beginning to create a synthesis of his various aims.

He died on 2 August 1788 of a cancerous growth on his neck, conscious of his dissipated life, but 'they must take me altogether – liberal, thoughtless and dissipated', as he put it. At his request his funeral was simple, and he was buried near his old friend Joshua Kirby in Kew Churchyard. His friend Bate eulogised him as 'one of the greatest geniuses that ever adorned any age or any nation'. Constable, in one of his lectures on landscape in 1836 also realised his particular merits. The most moving tribute was paid in Reynolds' 14th Discourse, but Constable's lecture on landscape in 1836 is equally sincere and heartfelt:

> The landscape of Gainsborough [and we might add his portraits too] is soothing, tender & affecting ... With particulars he had nothing to do; his object was to deliver a fine sentiment, the depths of twilight, and the dews and pearls of the morning, are all to be found on the canvases of this most benevolent and kindhearted man. On looking at them, we find tears in our eyes, & know not what brings them.

1

Self-Portrait

1754

Oil on canvas, 23×19½ in. (58.4×49.5 cm)
The Marquess of Cholmondeley

This rapidly painted, unfinished sketch, with the artist's tricorne hat jauntily tilted, is a private image of Gainsborough that, even at the age of twenty-six, he wished to emphasise. It is everyone's romantic idea of the artist as a gay dog. At a similar age Reynolds was painting himself with searching gaze, looking ahead to the future (National Portrait Gallery, London), and later he was to paint himself in academic robes against a bust of Michelangelo (Royal Academy, London).

Yet we must remember that, as Gainsborough wrote to his close friend, William Jackson: 'But don't be in a hurry to determine anything about *me*, if you are, ten to one you are wrong.' Gainsborough liked to spread about his reputation as an unthinking, happy-go-lucky artist, who enjoyed cocking a snook at the academic world of art, but as this sensitive image with its melancholy gaze shows, he had hidden depths. His knowledge of art, of life, and of the artist's position in society, was deep and thoughtful.

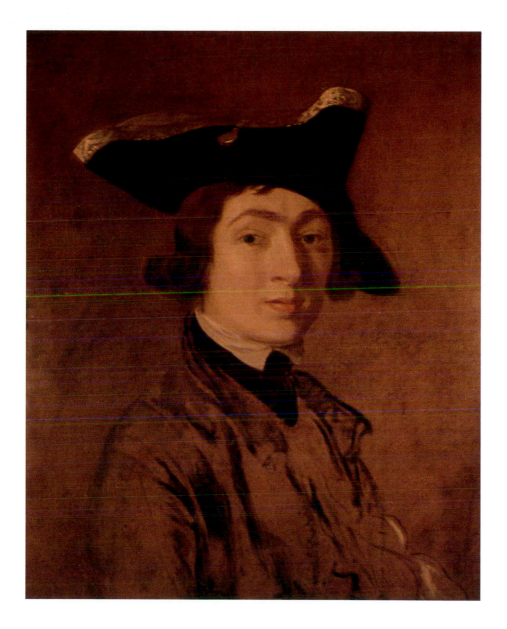

2

A Young Man and a Girl, perhaps the Artist and his Wife, in a Woodland Setting

c. 1746

Pencil, 7$\frac{15}{16}$×10$\frac{9}{16}$ in. (20.2×26.8 cm)

Musée du Louvre, Paris

A later inscription identified this drawing as representing *Mr P. Sandby and his wife*, but Sandby was not married until 1757. This early drawing shows a courting couple in a park-like scene with a wrought iron bench similar to that which appears in *Mr and Mrs Robert Andrews* (Plate 8). Some French influence in Gainsborough's art would have been expected from his early training under Gravelot, and this drawing reveals that not only was he aware of the tender courtship scenes of Watteau and his followers, but also of their draughtsmanship, with the generalised strokes of the park-like background and the incisive touches for the principal figures. There were paintings, drawings, and prints after Watteau available in England from which Gainsborough could have learned.

He has created, very probably, an allegory of his own courtship of Margaret Burr, whom he was to marry clandestinely in July 1746 in London. The combination of the emotional immediacy of the relationship between the couple and the artiness of the generalised background, with a cow introduced at the right as a realistic prop, already prefigures the creative inventiveness of his later work which owes as much to art as life.

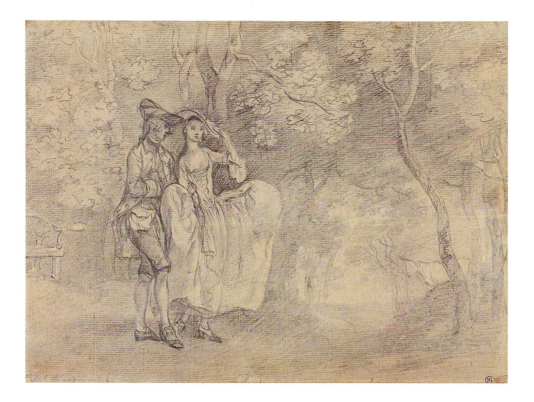

3

Rest by the Way

1747

Signed and dated bottom left: Gainsbro:/1747

Oil on canvas, 40⅛×58 in. (101.9×147.3 cm)

Philadelphia Museum of Art

This is a rare example of a signed and dated work by Gainsborough to which other similar landscapes, such as the three following, can be linked. His earliest drawings were of landscapes, and there is no doubt that he was a keen observer of natural effects, but he was equally enamoured of those small Dutch landscapes that he remembered with such affection at the end of his life. Jan Wijnants and, above all, Ruisdael, whose *La Forêt* he had copied, provided him with a repertoire of birch trees, winding tracks, and sunlit glades, with which he would ring the changes for commercial gain.

The traveller at rest, based on figures by Berchem, and the enigmatic figure at the left, provide 'a little business for the Eye to be drawn from the Trees in order to return to them with more glee', as Gainsborough later explained his aims. His figures have no allegorical significance apart from a general verisimilitude. Likewise, the animals are placed carefully throughout the picture to ease visual transitions from the middle to the background.

The unacademic liking for Dutch pictures and, by extension, their English imitations, is exemplified by the number of works which Gainsborough produced in this vein. The unusual elongated shape of the painting is, perhaps, an indication that it was intended as an overdoor, or overmantel, where such Dutch inspired views were very popular.

For all their debt to the art of seventeenth-century Holland, however, Gainsborough's early landscapes do not neglect the air of nature, and as Richard Dorment has so aptly described this particular example: 'The whole scene [is] permeated with the feel of a day in early spring, soon after a shower of rain, when the light in the blue sky is made fitful by swiftly scudding clouds.'

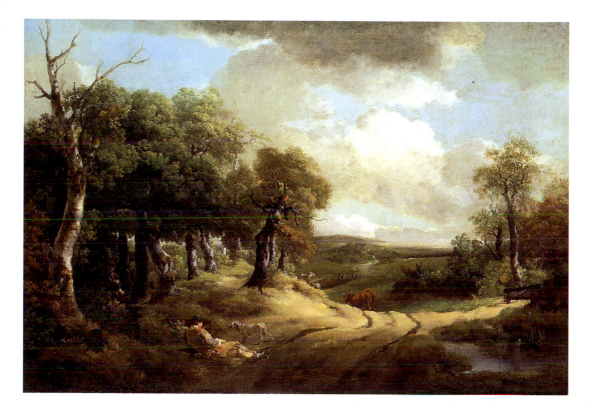

4

A Wooded Landscape with Figures and Animals; 'Gainsborough's Forest' *or* 'Cornard Wood'

c. 1746–8

Oil on canvas, 48×61 in. (121.9×154.9 cm)

The National Gallery, London

This celebrated early landscape by Gainsborough was once owned by David Pike Watts, Constable's uncle and mentor, and the later artist's affinity with this textured woodland scene is clear. The painting was first called 'Cornard Wood' when in Jesse Watts Russell's collection in the nineteenth century, but in 1790 it had been engraved as 'Gainsborough's Forest', perhaps an echo of Ruisdael. The church in the background does not appear to be St Andrew's, Great Cornard, which has a tall spire, but the landscape has an air of particularity that suggests it was based on an original track through the woods, near Sudbury.

The painting has generally been dated 1748, but a famous letter to his champion, Bate-Dudley, of 1788 complicates its history:

> It is in some respects a little in the *Schoolboy stile* – but I do not reflect on this without a secret gratification; for – as an early instance how strong my inclination stood for LANDSKIP, this picture was actually painted at SUDBURY in the year 1748; it was begun *before I left school*; and was the means of my Father's sending me to London ...

Gainsborough seems to be implying that the painting was begun and sold before 1740–1. He was precocious, but it is doubtful whether such a highly finished work, which compares well with other similar landscapes, was painted so early. He went on:

> It is full forty years since it was first delivered by me to go in search of those who had *taste* to admire it. Within that time it has been in the hands of twenty picture dealers, and I once bought it myself during that interval for *Nineteen Guineas*. Is not that Curious?

He criticised it himself for its lack of composition but thought 'the touch and closeness to nature in the study of the parts and minutiae are equal to any of my later productions ... '.

It is almost wholly in his early Dutch manner, with an obvious debt to Ruisdael in the sandy banks, the dock leaves, and patches of light through the trees, opening out to the distant view, while the figures and the highlights on the trees remind us what he had learned from Wijnants. In spite of the fact that Gainsborough was anxious not to seem 'vain or ridiculous' in its praise and that, like most artists, he preferred his 'riper performances', it is an impressive composition with a great mastery of detail and generalities which Constable would have admired.

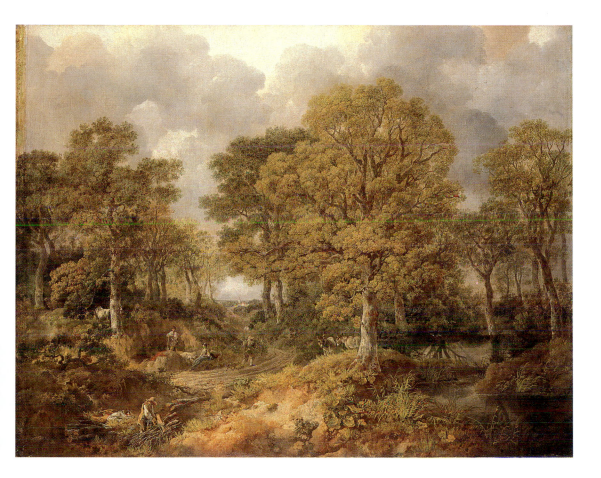

5

Charterhouse

1748

Oil on canvas, roundel diameter 22 in. (55.9 cm)
Thomas Coram Foundation for Children, London

Doubtless because of his connection with the St Martin's Lane Academy, and owing to the direct support of Hogarth, Gainsborough was included in a group of landscape painters who presented eight circular townscapes for the decoration of the Court Room of the Foundling Hospital. They represent views of London hospitals and, together with the major group of four narrative pictures by Hogarth, Hayman, Highmore, and Wills, they remain as a monument to the taste for rococo decoration in England during the 1740s. It was a significant achievement for the young artist, just twenty-one and newly married, particularly as 'a visit to the Foundling became the most fashionable morning lounge of the reign of George II'. Gainsborough's gift was recorded in the Committee's minutes of 11 May 1748, and the contemporary chronicler, George Vertue, thought it was the best of the series.

Gainsborough was not known for topographic landscape and his later aversion to such commissions is well known. His view of Charterhouse, with the Terrace Walk and the Great Hall, is, on the whole, very accurate. For such a specific commission and urban scene he has drawn on different Dutch prototypes from his other contemporary landscapes, in this case, the townscapes of Jan van der Heyden, of whose warm tonalities and careful drawing it is reminiscent. His friendship with Joshua Kirby clearly provided him with knowledge for his severe perspective angle, while his friend Hayman probably influenced the motif of children engrossed in their game of marbles.

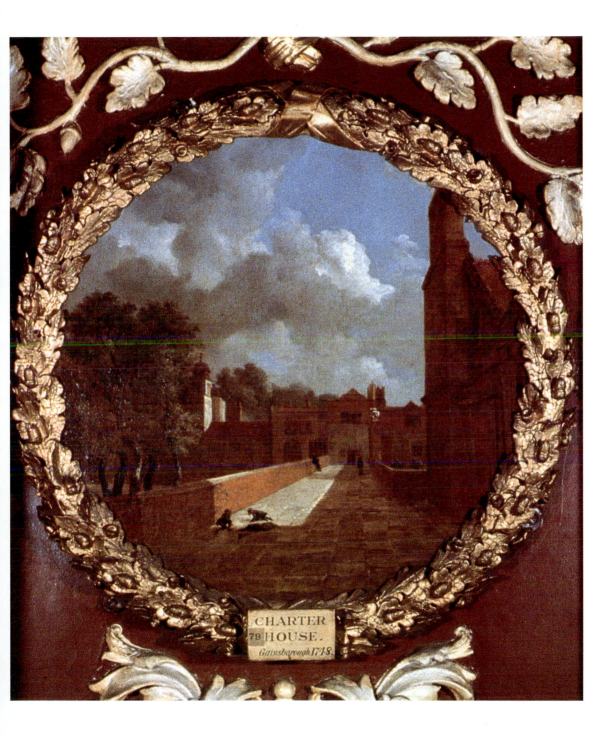

CHARTER
79 HOUSE.
Gainsborough 1748.

6
An Extensive River Scene
c. 1748–50
Oil on canvas; 30×50½ in. (76.2×151.1 cm)
The National Gallery of Scotland, Edinburgh

This elongated composition was probably intended as an overdoor, as Dutch landscapes were generally displayed. Not surprisingly, there are a number of Dutch antecedents for such an elaborate dune landscape, from Ruisdael to Wijnants for the motif of the winding trail, to Jan Both for the two conversing figures. The artificiality of the sinuous curves which underlie the structure remind us of Gainsborough's rococo beginnings and also suggest a knowledge of the contemporary art scene, and Hogarth's 'Line of Beauty'. There is, in addition, a sharp-eyed atmospheric panorama at the right, similar to the landscape at Yale (Plate 7), which shows Gainsborough's feeling for natural effects, perhaps tempered by a knowledge of baroque landscape. His later Suffolk admirer, Constable, was to learn the same lesson from Rubens.

The distant view has the convincing appearance of a real glimpse of the Stour Valley, and has been identified as Great Cornard, but it remains tantalisingly uncertain. Our eyes are held at the left by Gainsborough's flickering light and shade on the tree, and the fluttering draperies of the two figures passing the time, all painted with an immediate nervous touch.

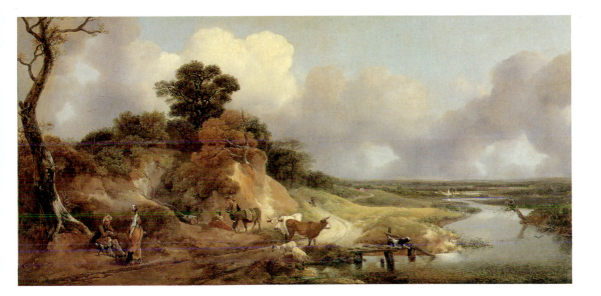

7
Wooded Landscape with a Cottage, Sheep, and Reclining Shepherd

c. 1748–50
Oil on canvas; 17×21⅜ in. (43.2×54.3 cm)
Yale Center for British Art, New Haven

Gainsborough's early landscapes have often been thought to be totally imaginary, but the small cottage at the left, and the field which falls away from it, have recently been connected, though without absolute certainty, with Abbas Hall, near Sudbury, with, possibly, a distant view of Great Cornard church, but with a smaller steeple than it actually has. The painting may, therefore, date after 1748 when Gainsborough returned to Sudbury.

The natural effects in this gem of a landscape are obvious enough in the details of the sheep and burdock leaves, and, above all, in the effect of bright sunlight on the central meadow. The light also catches the tree at the right and moves over the landscape beyond. The manipulation of light and shade equally owes as much to art, in the enveloping shadow of the foreground, and the shapes of the clouds which echo the velvety bank of dark trees in the background.

With the passage of time, however, the paint has become transparent and the reclining shepherd at the right is almost lost as the red ground has become more obtrusive. The picture, incidentally, was probably owned by James West of Alscott Park, a notable connoisseur.

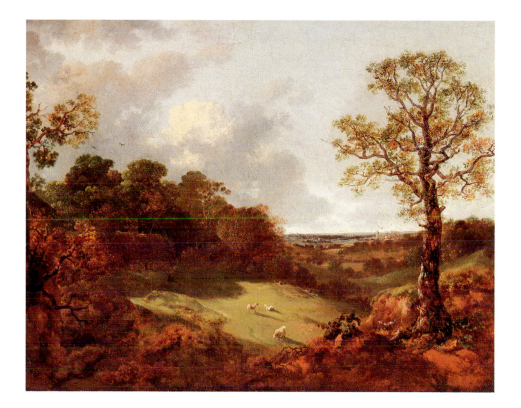

8
Mr and Mrs Robert Andrews

c. 1748–50
Oil on canvas, 27½×47 in. (69×119 cm)
The National Gallery, London

The 'conversation piece', or group portrait with more than one small figure in a natural setting, achieved popular success in the circle of Frederick, Prince of Wales, throughout the 1730s and 1740s. Following the principal examples of Hogarth, Hayman, Devis, and Philips, Gainsborough produced his own versions of this popular style, peopled by sitters who came from Suffolk, around Sudbury and Ipswich.

This example is the most famous, and the most English, of the group, and demonstrates his originality and imaginative qualities right at the beginning of his career. Less stolid than Hayman, certainly less wooden than Devis, yet without Hogarth's restless liveliness of character and touch, Gainsborough has, nevertheless, created a fresh masterpiece where portraiture and landscape are equal. The young couple, identified by family tradition as Mr and Mrs Robert Andrews, are seen against a naturalistic landscape reminiscent of, if not absolutely after, the countryside around Sudbury. The church in the background is similar to that of Little Cornard, or St Peter's, Sudbury, and in fact, the couple were married at All Saints, Sudbury in November 1748. This fact helps to date the picture to *c.* 1748–50.

Although Robert Andrews of Auberies (1726?–1806), near Sudbury, leans confidently in a fashionably cross-legged pose, which Gainsborough was to use in other pictures, his left arm does not quite support his weight on the wrought iron bench, while Mrs Andrews (née Frances Mary Carter, *c.* 1723–80) appears likely to slide off at any moment, as she nervously clutches to her best silk dress what Gainsborough may have intended to be a pheasant, but which, perhaps from a flash of common sense, he left unpainted. These naïve quirks of pose, possibly due to the use of lay figures, however, in no way detract from Gainsborough's complicated technique of painting, with flickering highlights appearing from an almost bare ground, and a ravishing landscape, whose rich harvest scene perhaps denotes fertility, or at least, the wealth of the local landowner's property. Gainsborough may have had much to learn professionally from Hayman, but he reaches a pitch of creativity and charm in this vein of painting which Hayman could never aspire to, and which Gainsborough himself hardly ever surpassed.

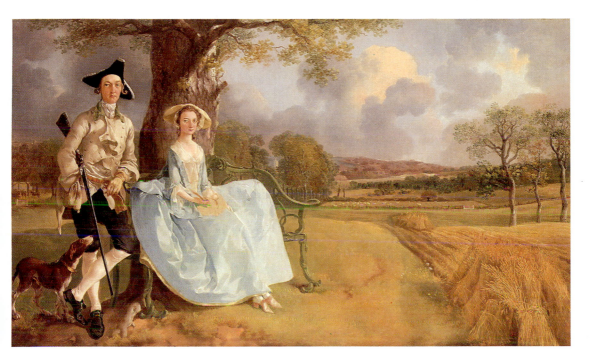

9

Heneage Lloyd and his Sister, Lucy

c. 1750–2

Oil on canvas; 25¼×31⅞ in. (64.1×81.0 cm)

Fitzwilliam Museum, Cambridge

A number of portraits have been connected with Sir Richard Lloyd (?1696–1761) and his family. Sir Richard, of Hintlesham Hall, near Ipswich, was a prominent local politician, being Recorder of Ipswich, 1739–61, and Solicitor-General in 1754. His portrait by Gainsborough is now in the National Museum of Wales, Cardiff. The children, so charmingly represented here, are probably Heneage Lloyd, the second son (1742–76), later a Captain in the Coldstream Guards, and his sister, Lucy, born 1740.

John Bensusan-Butt has identified the other portraits as Richard Savage Lloyd (1730–1810), with his mother, Lady Lloyd (née Elizabeth Field, 1707–73) (Yale Center for British Art, Paul Mellon Collection, New Haven), not his sister, Cecil, as was thought hitherto; and *The Girl Seated in a Park*, also at Yale, as Cecil, born *c.* 1734 (Plate 10).

Heneage and his sister are shown here fancifully portrayed in front of an elaborate rococo garden, with a balustrade, a lake, and a pavilion that were never at Hintlesham. Their rather awkwardly linked arms and slightly leaning poses are typical of the uncertainties sometimes found in the early work of Gainsborough, but he more than makes up for this in the decorative colour and sprightly sense of light and shade. There is a sympathetic sense of the two youthful sitters both holding bows and Lucy with her arrow. Because of their apparent age the picture may date from *c.* 1750–2, when Gainsborough moved to Ipswich.

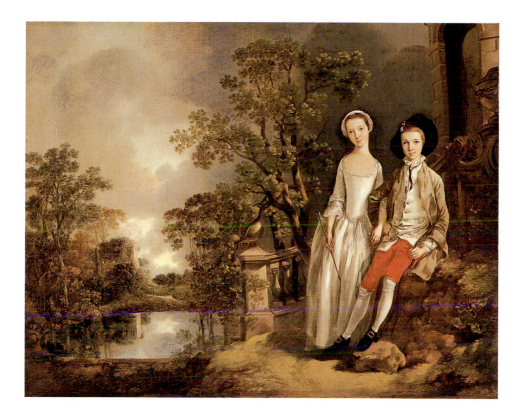

10

Girl with a Book Seated in a Park

c. 1750

Oil on canvas; 29⅞×26¼ in. (75.8×66.7 cm)

Yale Center for British Art, New Haven

This charming portrait has been linked with *The Lady and Gentleman in a Landscape* at the Dulwich Art Gallery, as they both once belonged to the same collector, John Doherty, of Birmingham, in the nineteenth century. Its similarity of pose and parkland setting to a portrait called *Miss Lloyd* (?) (Kimbell Art Museum, Fort Worth, Texas), for which there are three preliminary drawings in the Pierpont Morgan Library, New York, has also been remarked on. Furthermore, it is not dissimilar from another portrait of *c.* 1750, *A Lady with a Spaniel* (Huntington Art Gallery, San Marino, California).

John Bensusan-Butt has suggested that, in fact, the picture represents Cecil Lloyd, a member of the Lloyd family of Ipswich. A portrait of her mother, *Lady Lloyd, with her Son, Richard Savage Lloyd*, recently re-identified by him, is also in the Yale Centre for British Art. (See under Plate 9 for the other Lloyd portraits.) Cecil (*c.* 1734–91) would have been about sixteen, the approximate age of the sitter, in 1750, and the elaborate parkland scene is close to that in the portrait of *Heneage and Lucy Lloyd* (Plate 9) in the Fitzwilliam Museum, Cambridge. Apart from a general family rememblance, there is, at present, no further proof of identification.

Setting such portraits out-of-doors with rococo fountains, complicated garden statuary, and pavilions was something which Gainsborough would have seen in the work of his friend Hayman during the 1740s, for example, *Mary Chauncey* of 1748, also in the Yale Center for British Art. There is an obvious debt by both to Watteau.

There is a further connection to Hayman in the pose of Cecil Lloyd (?) which echoes that of a girl reading in a drawing by Hayman for *Ladies Angling*, a lost Vauxhall painting of *c.* 1741–2. The pose is also more or less identical, but in reverse, with the girl in the Fort Worth painting, including the crossed legs, and the urn on a plinth.

Hayman's sturdy professionalism at the time was obvious, and Gainsborough's figures were still a little uncertain in, for example, the hands, in this picture, but his lightness of touch and brilliant handling of the silk drapery show how, already by the end of the 1740s, Gainsborough is revealing that creative imagination which Hayman could not achieve.

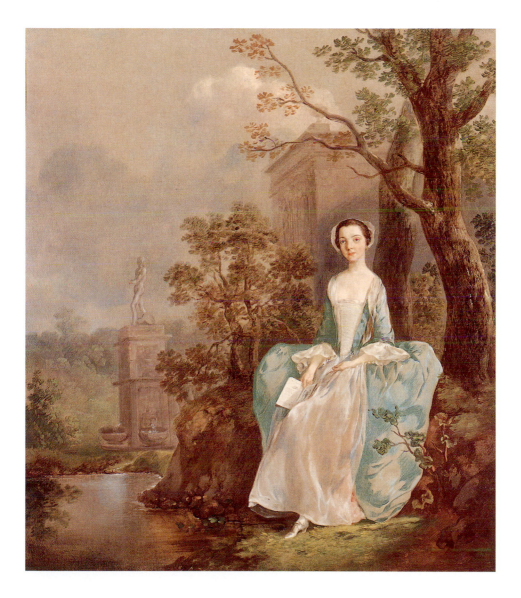

11

Mr and Mrs John Gravenor and their Daughters, Elizabeth and Ann

c. 1752–4

Oil on canvas, 35½×35½ in. (90.1×90.1 cm)
Yale Center for British Art, New Haven

Because of its similarities with *Mr and Mrs Robert Andrews* (Plate 8) and its obvious awkwardness of pose, the present picture has been dated as early as 1747. It would appear, however, that these early conversation pieces by Gainsborough cannot be organised in a convenient stylistic chronology that moves from a seeming gaucheness to greater sophistication between 1747 and 1754.

John Gravenor (1700–78) was an apothecary of Ipswich who was to become prominent as a local politician around 1754. He is shown with his second wife, Ann Colman, whom he married in 1738/9, and his two daughters, Ann (baptised January 1739/40), who inherited the picture, and Elizabeth Broke Gravenor (*c.* 1742–1819). The picture has been dated as late as 1754 because of the apparent age of the girls as fourteen and twelve, but they may be a little younger, say twelve and ten in 1752, when Gainsborough moved to Ipswich from Sudbury.

In spite of the faint air that the sitters are pushing their heads through a seaside photographer's canvas, while they fall gently sideways, the painting must be later than *Mr and Mrs Robert Andrews* (Plate 8), to which the wheatfield and the distant Suffolk landscape are so similar. Gainsborough has achieved a dazzle of shot silk and surface flicker by the most complicated means, in spite of obvious weaknesses in the anatomy of the figures. He may owe a debt to his early mentor, Francis Hayman, whose portrait of the *Jacob Family* of *c.* 1743–4 is very like Gainsborough's group, but Gainsborough's sensitive feeling for the individuality of his sitters in, for example, the nervous youthfulness of the two girls, and his characterisation of the proud mother with her fashionable straw hat of *c.* 1750, presage his later comments on the necessity of getting a 'Likeness, the principal beauty and intention of a Portrait'. He was to achieve other convincing portraits of Ipswich notables.

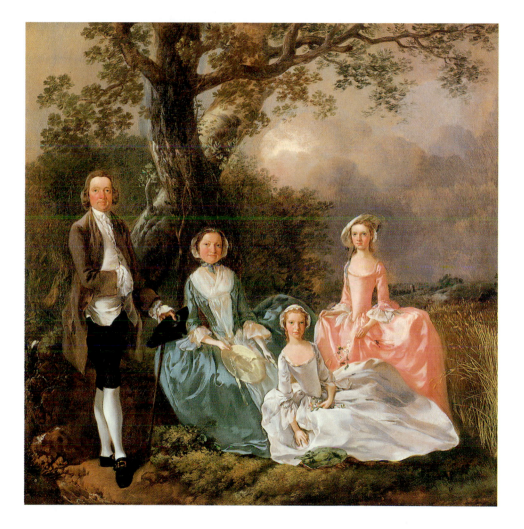

12

John Plampin

c. 1753–5

Oil on canvas; 19¾×23¾ in. (52.0×63.0 cm)
The Tate Gallery, on loan to the National Gallery, London

John Plampin (*c.* 1726–1805) of Chadacre Hall, near Lavenham, outside Sudbury, Suffolk, was one of a number of local sitters with country estates whom Gainsborough painted when he returned to Suffolk from London. Plampin is shown sprawled on a sandbank set against a wide vista of a landscape. The slightly awkward pose derives from a lost Watteau portrait of his friend Antoine de la Roque which was also known in reverse from its engraving by B. Lépicié of *c.* 1734. De la Roque, however, had a reason for keeping his leg out rather stiffly; he had been wounded at the Battle of Malplaquet, whereas Plampin, presumably, is posed in such a way, with one hand fashionably tucked into his waistcoat, to give an air of casual elegance.

Hayman was to use the same pose in a number of works, *The Wapping Landlady*, his double-portrait of *David Garrick and William Windham*, *c.* 1745, and *Philip Thicknesse*, at St Louis, previously attributed to Gainsborough himself.

The landscape background of Gainsborough's portrait and the overall composition are closer in style to the French rococo than to the Dutch examples which so influenced his early work. The brushstrokes over the whole surface have begun to take on almost an independent life of their own, and no longer describe objects so realistically, while the structural lines of the composition, the branches, the sitter's legs, and the dog, create a whirling design which radiates out from the centre. Because of these characteristics, a date of near to 1755 is preferred.

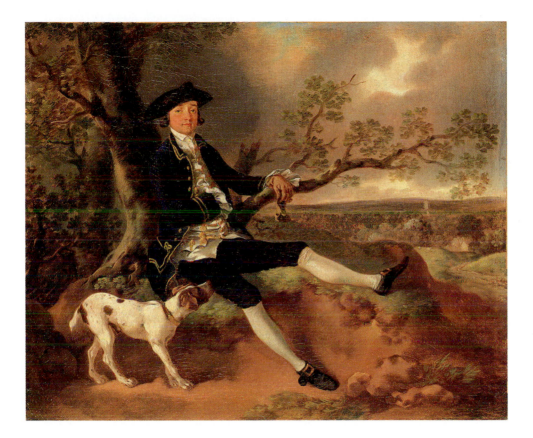

13

Self-Portrait

c. 1750–5

Pencil on two pieces of paper, the figure cut out and laid down on a landscape background; 13⅞×10⅛in. (35.2×25.7 cm)

The British Museum, London

Gainsborough's artistic beginnings were as much concerned with graphic art as painting, and his love of drawing for its own sake is well documented throughout his career. As well as delivering painted landscapes 'to go in search of those who had *taste*' to admire them, he obviously created drawings for the same quest. Panton Betew, a dealer through whose hands passed a number of Gainsborough's early works, recounted to J. T. Smith: 'Well, and then there was your great Mr. Gainsborough, I have had many and many a drawing of his in my shop-window before he went to Bath; ay, and he has often been glad to receive seven or eight shillings from me for what I have sold: Paul Sandby knows it well.'

By the beginning of the 1750s Gainsborough had also embarked on making prints himself, as well as working with Charles Grignion and Joseph Wood. This self-portrait, with the artist seen not directly, as in his painted portrait (Plate 1), but as if he were someone else seen in profile, and drawn in reverse with his pencil in his left hand (Gainsborough was right-handed), suggests that he had a public stance in mind, with a published print as the end result, which would reverse the composition. The fact that he has cut out the figure and placed it against a landscape background seems to support this suggestion.

The idea, and indeed the frothy execution of the landscape background, are other examples of Gainsborough's debt to the French rococo style, and, in particular, to Watteau, whose self-portrait with Jullienne, engraved by Tardieu, embodies similar notions of the artist taking his inspiration from nature.

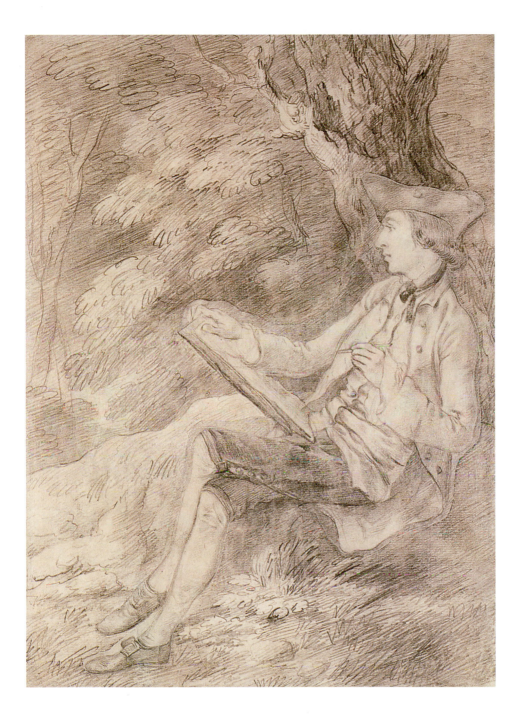

14

A Landscape with a Woodcutter Courting a Milkmaid
1755
Oil on canvas; 42×50½ in. (106.7×128.2 cm)
Marquess of Tavistock and the Trustees of the Bedford Estates

This painting was purchased from the artist by John, 4th Duke of Bedford (1710–71) in November 1755, as the existing receipt for 21 guineas testifies. An account book at Woburn also shows that 8s 2d was paid for 'carriage and porterage of a picture from Ipswich' on 31 May 1755. It is a pair with a landscape of a boy on a horse with haymakers in the background, still in the same collection.

The Duke of Bedford was a celebrated connoisseur and collector of pictures in the circle of Frederick, Prince of Wales. He was in the process of redecorating Bedford House in London and Woburn Abbey, Bedfordshire, during the 1750s. He had earlier commissioned naturalistic landscapes by Lambert of scenes of Bedford estates and of Boxhill, Surrey (Tate Gallery and Yale Center for British Art), and was to put together an impressive series of Canalettos which are still at Woburn. He obviously realised the merit of the young, rising artist, who aimed to paint in the best contemporary style: in this case a very French 'chimney-piece' of rustic courtship, probably intended for Woburn. It comes close in mood to pictures by Fragonard.

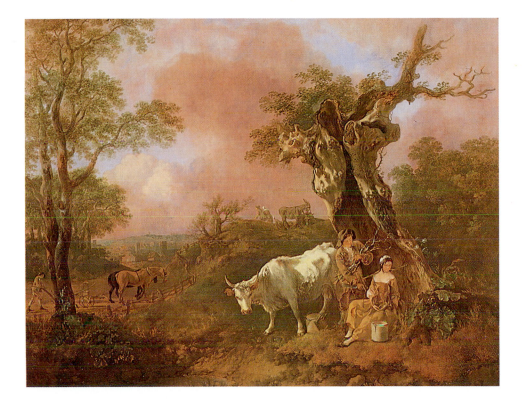

15

The Painter's Daughters Chasing a Butterfly

c. 1756

Oil on canvas; 44¾×41¼ in. (113.7×104.8 cm)

The National Gallery, London

No more enchanting vision of an artist's children exists. Rembrandt had drawn his child's first faltering steps, Constable, a proud parent, produced a loving depiction of his children playing at coach and horses, while Monet painted a number of shimmering pictures of Camille and Jean, but none catches the earnest simplicity and tentative movement of childhood that Gainsborough created in this private vision of his two daughters, Margaret (1751–1820), then aged about four, and Mary (1748–1826), aged about eight, chasing after a butterfly.

He was to paint other moving images of his two daughters throughout their life but none has such an emotional appeal. The symbolism of the fragility of life with the children with linked hands reaching for the butterfly had no parallels in eighteenth-century European portraiture, except, perhaps, for the studies of children building a house of cards by Chardin. Reynolds' portraits of children can be pert, even amusing, but never so immediate.

With the wisdom of hindsight, we can see the irony of the portrait. 'Molly and the Capt.' as he sometimes called them, were taught to draw, and a later portrait of *c.* 1763–4 at Worcester, Mass. shows them with portfolio in hand. Mary, the elder, entered into an unfortunate short-lived marriage with Fischer, the oboist (see Plate 50), much to her father's distress, and she eventually declined into insanity. She lived out her years at Acton, with her spinster sister Margaret, who died aged 68. Mary died in 1826, aged 78. They were both buried at St Mary's, Hanwell.

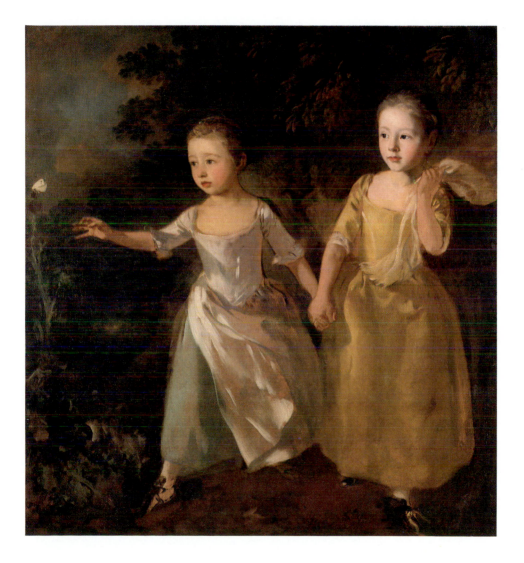

16

The Hon. Richard Savage Nassau

c. 1757

Oil on canvas; 49×38¾ in. (124.5×98.4 cm)

The National Trust for Scotland

During his period in Suffolk, Gainsborough painted very few large portraits on the scale of life to a standard size of 50×40 in. He was slow to adopt the prevalent manner of more fashionable portraitists for 'half-lengths', such as those during the 1740s by Van Loo, Soldi, and Hudson, closely followed by his pupil, Reynolds, during the 1750s. His principal source of income was through portraiture: 'But business comes in, and being chiefly in the Face way I'm afraid to put people off when they are in a mind to sit', he wrote to William Hayhew at Colchester. He was only receiving 15 guineas for such a size before he went to Bath, and his conversation pieces with more than one figure may have fetched in more, being paid by the head, while the Suffolk squirearchy with smaller houses may have been perfectly satisfied with the small portrait, a middle-class taste that Mason Chamberlain exploited in London.

When he came to paint an aristocratic patron he took more pains, as the following drawing (Plate 17) shows, and painted on a larger scale. The sitter (1723–80) was the younger son of the 3rd Earl of Rochford, who had married the widow of the Duke of Hamilton with estates in Suffolk. They lived at a grand house, Easton Park, near Ipswich.

In spite of its size, however, the painting is remarkably informal, as Gainsborough sits him sideways on his chair, caught looking up from his book as if stirred by thought. Gainsborough has also added one of his own improvised landscapes on the wall behind.

17

Study for the Portrait of the Hon. Richard Savage Nassau

c. 1757
Black chalk; 11⅛×8 3/16 in. (28.2×20.8 cm)
Staatliche Museen, Preussischer Kulturbesitz, Berlin

Very few compositional studies by Gainsborough are known for his portraits. He tended to paint directly onto the canvas, with the many alterations that have often become more obvious with time. For an important portrait (see Plate 16) he obviously took great pains but, as was the practice with Reynolds, his drawings are mainly concerned with the main outlines of the pose, and the sinuous lines of the draperies expressed with rapid thick strokes of the chalk. The likeness he left to his painting.

18
William Wollaston
c. 1758
Oil on canvas; 47½×38½ in. (126.0×97.8 cm)
Ipswich Museums and Galleries, Suffolk

The sitter (1730–97), of Finborough Hall, Suffolk, was later MP for Ipswich. He may have been a friend of the artist possibly because of their common musical interests. Wollaston is shown here as an amateur flautist, twisting round as if to greet a visitor. As with the portrait of *The Hon. Richard Savage Nassau* (Plate 16), Gainsborough adds to the interest of a caught moment a remarkable flutter of lines, with the blue coat set off by its white silk lining, and the gold braiding providing a rich decorative effect on the crimson waistcoat. He was also to paint the sitter in his earliest surviving full-length at about the same time.

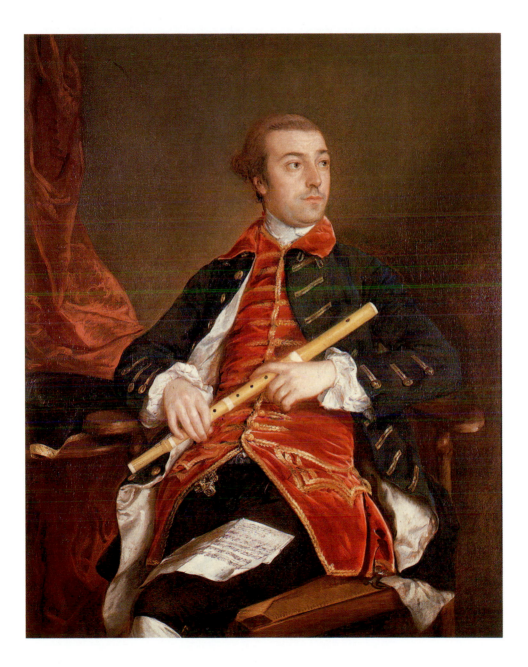

19
Ann Ford, later Mrs Philip Thicknesse
1760
Oil on canvas; 77½×53 in. (196.9×134.6 cm)
Cincinnati Art Museum

The sitter, Ann Ford, (1732–1824), married Gainsborough's early patron, Philip Thicknesse, in 1762. She was an amateur musician with some pretensions in her art, giving recitals in London during 1760 on the viol da gamba, and guitar (or cittern, as it has been identified).

For such an impressive full-length, his first on his arrival in Bath, he has been influenced by Van Dyck, principally by the portrait of *Lady Digby*. He has, however, created a bold, twisting composition which goes beyond the studied elegance of Van Dyck. Not surprisingly for such a complicated composition, a preliminary drawing exists in the British Museum, London while another in the Pierpont Morgan Library, New York, may also be connected with it, particularly for the fall of light on the drapery. For these he may have used mannequin dolls.

Although the composition can be described as 'rococo' in the use of the curved 'Line of Beauty', and scalloped decoration, which, perhaps, goes back to his earliest association with Gravelot, the sheer impact of its size, the baroque fall of the red curtain, and the proud pose of the sitter go beyond any French example. That Gainsborough has gone too far, even deliberately so, can be judged by the contemporary comments of Mrs Delany who saw the portrait in the artist's studio on 23 October 1760: 'They are *splendid impositions*. There I saw Miss Ford's picture, a whole length with her guitar, a most extraordinary figure, handsome and bold; but I should be very sorry to have any one I loved set forth in such a manner.'

With the opportunity of the further study of Old Masters in and around Bath, he was to learn to tame his exuberance, and, of necessity, suppress any tendency to caricature to become a successful professional portraitist.

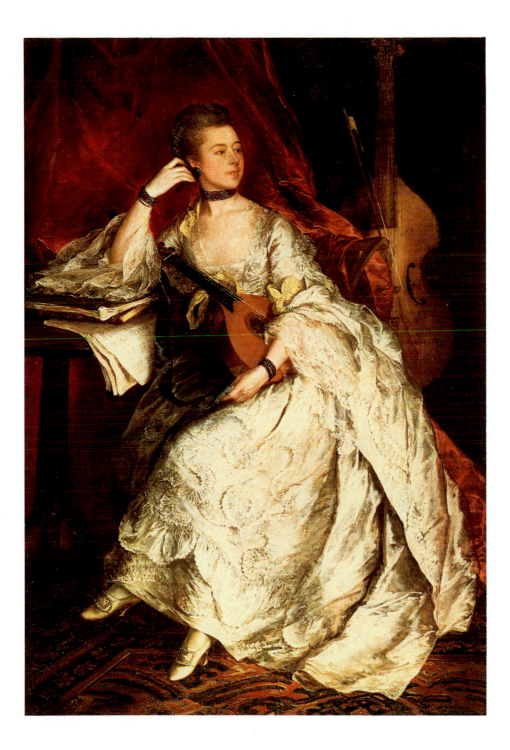

20

Beech Trees at Foxley, with Yazor Church in the Distance
1760

Brown chalk, with watercolour and body colour over pencil;
$11\frac{5}{16} \times 15\frac{3}{16}$ in. (28.7×38.9 cm)
Signed and dated on paper pasted on verso: 'Tho: Gainsborough del 1760'
Whitworth Art Gallery, University of Manchester

Gainsborough seems to have made friends with the Price family of Foxley, in Herefordshire, soon after his arrival in Bath. He painted a portrait of Uvedale Tomkyns Price, now in the Neue Pinakothek, Munich, which shows him pausing for inspiration, as it were, in the act of drawing, with one of Gainsborough's drawings on the wall behind. Gainsborough is also known to have painted a portrait of his son, Sir Robert Price, Bt, the proprietor of Foxley. Gainsborough was also to become friendly with the grandson, Sir Uvedale Price (1749–1829), best known for his writings on the Picturesque, on which Gainsborough may well have had some influence.

Lindsay Stainton has perceptively drawn attention to a particularly apt quotation from Uvedale Price which could well fit this drawing. The drawing, incidentally, is identified by an old label as 'A study from nature, by Gainsborough when on a visit to Foxley ...'. Price describes a country lane: 'It had on one side a high bank full of the beauties I have described; I was particularly struck with a beech which stood single on one part of it, and with the effect and character which its spreading roots gave, both to the bank and to the tree itself ...' (*Essays on the Picturesque*, 1794).

This highly finished drawing may have been brought to completion away from the actual motif, but it embodies all the 'varieties of form, tint, and light and shade, – every deep recess – every bold project – the fantastic roots of trees – the winding paths of sheep' which characterise Gainsborough's landscape art from 1760 onwards, and which can be described as Picturesque. It can be related to a finished painting executed at Bath *c.* 1760 for his friend, Samuel Kilderbee, which is almost identical in composition, but to which Gainsborough has added a woodcutter, a mounted peasant, and another horse.

21
William Poyntz
1762
Oil on canvas; 92½×60 in. (234.9×212.4 cm)
Earl Spencer, Althorp, Northants

Gainsborough's early portraits painted in Suffolk had already exploited 'in little' the idea of a sportsman at ease in nature. *Major Dade* of the late 1750s (Paul Mellon Collection, on loan to the Yale Center for British Art, New Haven) is one such, cleaning his gun with his two dogs at his feet, while in the more formal setting of his conversation piece, *Mr and Mrs Robert Andrews* (Plate 8), the husband has his gun, and the wife, less enthusiastically, holds the bird.

In Bath, for his second exhibit at the newly established Society of Artists in London, he has translated these informal sporting images of his Suffolk career into a large full-length. William Poyntz (1734–1809) of Midgham, the son of the Rt. Hon. Stephen Poyntz, was the brother of the 1st Countess Spencer. He is shown nonchalantly leaning against the hollow tree with attendant dog, transposed from his earlier landscapes. The variant of the 'cross-legged' pose is reminiscent of his first full-length of *William Wollaston* (Trustees of the late H. C. Wollaston). By 1762, however, the landscape background is no longer a plausible view in Suffolk, but has become a generalised flicker of leaves and clouds that serve to emphasise the movement of the overall design.

22

A Hilly Landscape with Figures Approaching a Bridge

c. 1763

Watercolour and body colour; 10⅓₆×14⅞ in. (27.5×37.6 cm)
Yale University Art Gallery, New Haven

If he was not a 'learned' artist in the manner of his rival, Reynolds, there is every evidence that Gainsborough was well aware of contemporary trends in landscape and portraiture. His finished drawings, of which this example was probably given to his doctor in Bath, Dr Rice Charlton, were personal explorations into the range of technical possibilities. His early drawings were influenced by the contemporary taste for Dutch and French styles that were fashionable in the 1740s and 1750s. When, however, Consul Smith sold his collection to George III in 1762, not only was Zuccarelli well represented, whose 'lighter style' had been commended to Wilson in about 1758, but there was also a group of landscapes by Marco Ricci (1676–1730), executed in gouache. Giovanni Battista Busiri (1698–1757?) was also represented in English collections, notably that of Gainsborough's friend, Sir Robert Price (Plate 20). His friend, Paul Sandby, also worked in this medium.

These gouache landscapes provided an example of a generalised Italianate landscape painted in a dense medium that could stand on its own. They would have appealed to Gainsborough, whose penchant for experimentation in the graphic arts had already been apparent.

This particular example makes much use of opaque white to accentuate the surface texture. Henceforth, he was to blur the distinction between the various media; pastel (his principal rival in Bath, William Hoare, was well known as a pastellist), oil painting, watercolour, and chalk drawing were all manipulated in a highly personal way.

The subject matter has also become more generalised, with a Claudian bridge, Italianate peasants, and a Gaspard Dughet-like distant vista translated into a rocky 'picturesque' landscape, 'somewhere near Bath'. It is unified by the medium into a sophisticated composition of brilliant accents of light and shade.

23
Mary Little, later Lady Carr

c. 1763

Oil on canvas; 50×40 in. (127.0×101.6 cm)
Yale Center for British Art, New Haven

This relatively unknown work has, since its recent cleaning, been revealed as a ravishing example of Gainsborough's new Bath style. There are impressionist touches of pure colour, pink and green, on her hands, and there is an exquisite clash of complementary colours, with the green of the leaves and pink and white of the flowers on her corsage. Her pink silk dress is very thinly painted, or rather drawn with the tip of his brush, in feathery pen-like strokes. By leaving the light-brown ground showing through, the picture has an added translucence, in the hair and dress particularly. There are many *pentimenti* around the head and shoulders. He has, however, above all, been influenced by Van Dyck and Lely.

The sitter, born Mary Little, was the second wife of Robert Carr (1707–91), mercer, of Ludgate Hill, who assumed the title of Sir Robert Carr, Bt, on the death of his brother, Sir William Carr, Bt (1703–77). The family lived at Etal in Northumberland, but on Sir William's death the estates passed to his daughter, Isabella, who had married the 15th Earl of Erroll. Sir Robert built Carrville in the parish of Walker, Northumberland, and was buried at Hampton. The painting descended to his daughter, Mary, who married William Parker Hamond of Haling, Surrey, later of Pampisford Hall, Cambridge.

The painting can be dated on stylistic grounds *c.* 1763, and can be compared to other early Bath portraits such as *Mrs William Leybourne*. It is not known when Robert Carr visited Bath, but the portrait may have been painted on the occasion of their marriage.

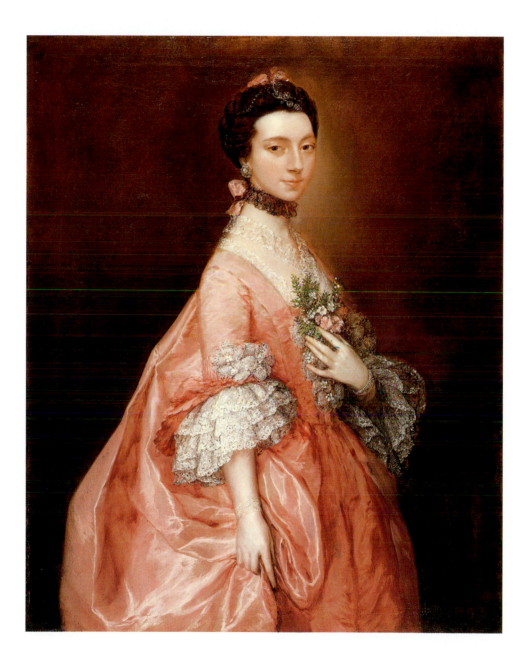

24

A Woman with a Rose

c. 1763–5

Black chalk and stump, heightened with white on greenish-buff paper,
18⅟₁₆ × 13 in. (46.6 × 33.0 cm)
The British Museum, London

This is one of a number of full-length studies which Gainsborough seems to have felt were necessary at the beginning of the 1760s, as he embarked upon a series of fashionable full-lengths. Not all of them can be connected with known paintings, but Lindsay Stainton has connected this drawing, and another in the Ashmolean Museum, Oxford (Plate 25), with one of the most important, and most beautiful, of his early portraits painted in Bath, that of *Mary, Countess Howe* (Plate 26).

Unlike the rapidly sketched compositional study which exists for *Mrs Thicknesse* (Plate 19), this group can been seen equally as drapery studies, taken sometimes from a lay model, or sometimes from the life. His possible first idea for *Countess Howe* shows her moving in profile from right to left, holding a rose in her right hand, with her drapery bunched up in her left. The finished pose is much less reserved, and turns boldly towards the spectator. Nevertheless, certain essentials are already visible in this charming sketch: the soft silk of her draperies overlaid with a decorated apron, lace ruffles at her elbow, and the beribboned straw hat, known as a 'Leghorn' bonnet. The drawing, with its delicate and varied strokes of chalk, is even more ephemeral than the finished picture. The landscape through which she moves in Van Dyckian elegance is suggested by the burdock leaves in the lower right foreground.

Such atmospheric drawings show how closely related were his drawings and paintings, even at this stage in his career, and how much he was fascinated by the sheen of fabrics and details of accessories, such as the necklace on a black silk choker, not worn in the finished picture. They look forward to a similar series of drawings done later in his career, possibly connected with *The Richmond Water Walk* (Plate 58).

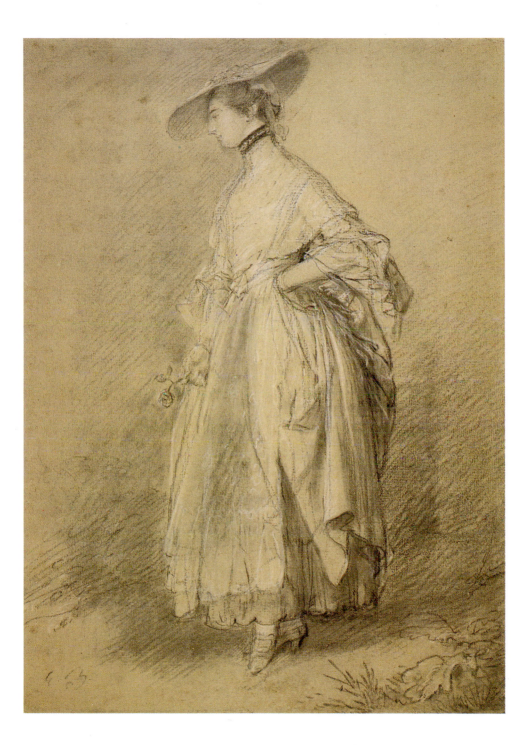

25

Study of a Woman Seen from Behind

c. 1763–70

Black chalk and stump with white chalk on greenish-brown paper,
19⅜×11⅞ in. (48.8×30.4 cm)
Ashmolean Museum, Oxford

If the previous drawing can be connected particularly with the portrait of Countess Howe then, perhaps, the Oxford drawing can be related in a general way to the problems Gainsborough had to face with a Van Dyckian ideal of elegance and subtlety of pose – not that any sitter would be flattered by a rear view. He was probably concerned, as John Hayes has commented, with the problem of how 'the folds and flounces of ladies' dresses would fall when in movement'. A pretty view of a nicely turned ankle, revealed by the hand which lifts up the dress from behind as the figure steps forward, is the overriding intention of this lively sketch, and the model actually wears a hat much larger than that worn by Countess Howe. The broader use of chalk may date this drawing to later in the sixties. At one time it was thought to represent Mrs Gainsborough going to church.

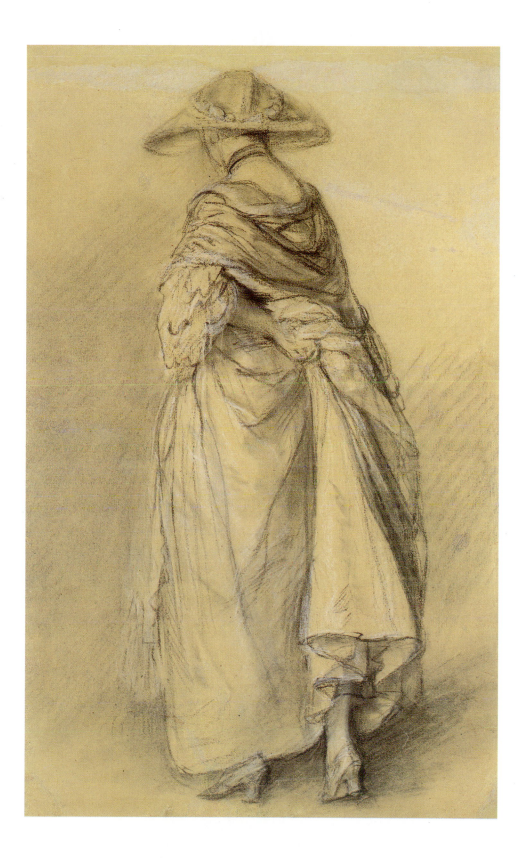

26

Mary, Countess Howe

c. 1763–4

Oil on canvas, 95¾×60¾ in. (243.2.×154.3 cm)

The Iveagh Bequest, Kenwood, London

No other portrait of Gainsborough's early career catches so well the elegance he quickly learned from Van Dyck when he moved to Bath. It is only about the third full-length of his career, and the visible changes show how much he altered the figure before he reached the charm of the finished image, which is now generally accepted as one of his masterpieces.

Mary Hartopp (1732–1800) married Richard Howe, later 1st Earl Howe (Plate 27), in 1758 at Tamerton Foliot Church, near Plymouth, where her father was Governor, but the portrait was probably painted later, *c.* 1763–4, when the couple were in Bath. Her husband had succeeded to the Viscountcy, and was a triumphant participant of the Seven Years War, which had ended in 1763. This, and its pendant, the portrait of her husband (Plate 27), were possibly intended for their London house in Grafton Street.

The availability of Van Dyck's portraits near Bath (see Introduction, pp. 18–19) taught Gainsborough a new aristocratic elegance with which to flatter his sitters. Lady Howe seems to float through the landscape towards the spectator, with delicate gestures of holding her decorated apron with one hand, while in the other she holds her glove. She is dressed in a fashionable 'night-gown' of pink silk, with a straw hat, known as a 'Leghorn' bonnet worn over a lace cap. It is in these fashionable accessories, such as the ruffles of her sleeves, the pearl necklace and earrings, and the black silk bracelet, as well as the fluttering backdrop of the park landscape, that Gainsborough has invested his talent for painterly effect.

We know, however, from the obvious changes, revealed even more clearly by recent X-rays and infra-red photography, how much care he took to achieve these details to his satisfaction. The position of her feet and the main twist of her pose also caused him some trouble. In spite of the use of the drawings (Plates 24 and 25), the whole seems to have been carried forward in fluid, thin paint, all over the canvas, in a masterpiece of improvisational brushwork. This provides such telling details as the thistle snagging her dress at the lower left, and changes to the birch tree at the right, which give an opening into space and, at the same time, a framing element. Only Ramsay and Reynolds could create such powerful images and match his sympathy for the sitter. The pastel effect looks forward to his ethereal portraits of the 1780s.

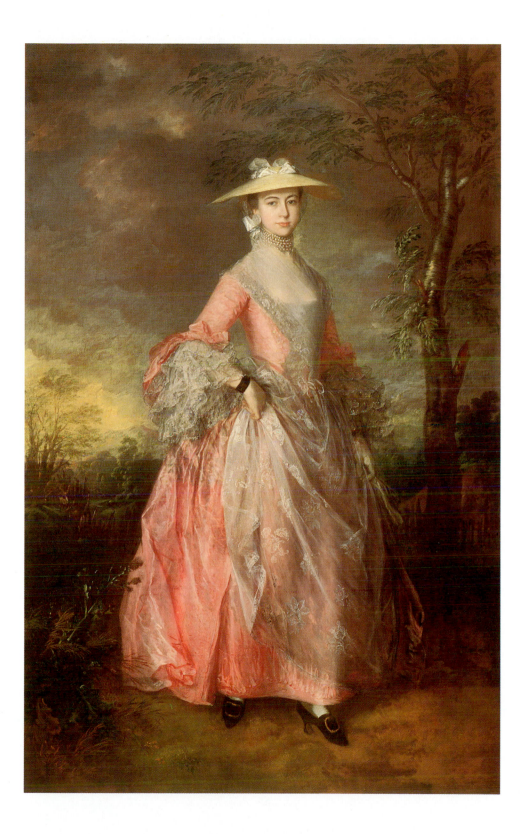

27
Richard, First Earl Howe

c. 1763–4

Oil on canvas, 95×60¾ in. (241.2×154.3 cm)

The Trustees of the Howe Settled Estates

Richard, Earl Howe (1726–99) is posed much more conventionally than the sympathetic portrait of his wife, in the all too prevalent cross-legged pose, which Gainsborough and his contemporaries adopted for male casual elegance (see Introduction, p. 16).

The sitter was of a similar age to the painter, but whereas Gainsborough was just making his mark on the London scene, Richard Howe was already a considerable success in his chosen naval career. He had sailed around the world with Lord Anson in 1740, and had been in frequent action by the year of his marriage in 1758, when he was already a Commodore and MP for Dartmouth. On the death of her father in 1759, Lady Howe added to the extensive family fortunes. Howe succeeded to the Viscountcy on the death of his elder brother in 1758, and was to be created Earl Howe in 1782. He had a very successful naval career, and was much loved by his men, contributing a major role in settling the seamen's mutiny at Spithead in 1797.

When he sat for Gainsborough he had been made Commissioner of the Admiralty, and was ashore for the first time in nearly eighteen years. He visited Bath in 1763 and 1764, undoubtedly searching for a cure for the gout from which he suffered. He seems to have made a part payment to Gainsborough of £32 10s in July 1763.

Gainsborough has painted Howe in what was by 1763 the everyday (undress) uniform of a Commodore, a double-breasted coat of blue, faced with white and decorated with gold lace. The portrait has very little of the overall attention to detail which makes the portrait of his wife such a ravishing example of Gainsborough's art, and seems to have been painted quite rapidly. It is a quite conventional portrait of an arrogant young sea-dog, owing much to Hudson, and has very little of the heightened dramatic thrust of Reynolds's portrait of *Lord Keppel* (1753–4), which had had such an effect on the art world of the 1750s.

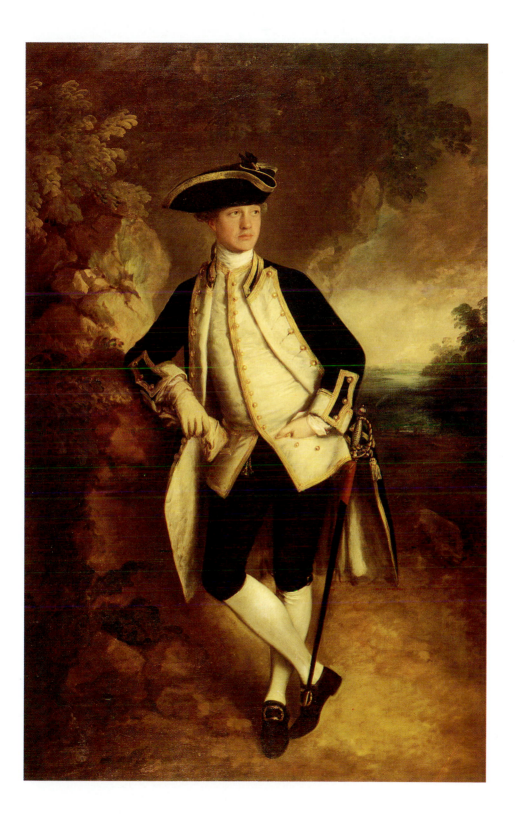

28
A Woodland Pool with Rocks and Plants
c. 1765–70
Black chalk with watercolour and body colour, varnished
9×11⅛ in. (22.9×28.3 cm)
Yale Center for British Art, New Haven

Gainsborough's friend, the musician and amateur artist William Jackson of Exeter, felt that:

> If I were to rest his reputation upon one point, it should be on his Drawings. No man ever possessed methods so various in producing effect, and all excellent … The subject, which is scarce enough for a picture, is sufficient for a drawing, and the hasty loose handling, which in painting is poor, is rich in a transparent wash of bistre and Indian ink.

It was to Jackson that Gainsborough was to confide his secret and elaborate method of mixing oil, chalk, white heightening, and varnish to produce 'Effects', of light and dark, best appreciated in the candlelight by which they had been drawn.

This particular example was once considered to be a realistic drawing of a rocky landscape near Bath, but it is more likely to be an artificial composition, based on arrangements of 'roots, stones and mosses, from which he formed, and then studied foregrounds in miniature' (Uvedale Price). Its dramatic effects of light and dark could be used as a foreground to his finished pictures, or as a spontaneous vision in its own right. In this respect he continues a rococo tradition of the virtuoso performance, of which his love of art and music were part. These 'performances' were appreciated by eighteenth-century connoisseurs who looked at the inspirational sketch as evidence of genius, as Reynolds later admitted. Gainsborough's blurring of the distinction between media, however, between a private sketch and a finished exhibited picture, and his obsession with individual creation look forward, equally, to nineteenth-century attitudes.

29
The Harvest Waggon
1767

Oil on canvas; 47½×57 in. (120.7×144.8 cm)
The Barber Institute of Fine Arts, The University of Birmingham

Traditionally, the picture was painted at Shockerwick Park, near Bath, and was given in 1774 to the artist's friend, Walter Wiltshire, the Bath carrier who lived there: Horace Walpole thought it 'very rich, the group of figures delightfully managed, and the horses well drawn, the distant hill one tint too dark'.

Gainsborough sent only two major landscapes to the Society of Artists in London after his move to Bath before he exhibited this masterpiece there in 1767. In it he has invested all his study of local collections, and all that he had learned from Gaspard Dughet, Claude, Berchem, Cuyp, and, above all, Rubens.

It has a more complex arrangement of figures with a greater anecdotal significance than anything he had attempted before. An oil sketch by Rubens for his altarpiece at Antwerp of *The Descent from the Cross*, then at Corsham, was copied by Gainsborough, and the pyramidal arrangement of tumbling figures bears a resemblance to Gainsborough's composition. Paul Hills has suggested a connection to the figures at the right of Raphael's fresco of *The Fire in the Borgo* in the Vatican, known from engravings, but it is clear that the man in the cart is helping the women up, not down. The drover is also reminiscent of one of the *Quirinale Horsemen*, so perhaps Gainsborough reveals an interest in the art of the past that is usually thought of as Reynolds' prerogative.

Gainsborough used his daughter Margaret as a model for the figure climbing into the cart, and his daughter Mary for the woman in the waggon. He also made, unusually for him, studies for the cart (Coll. Lord Knutsford), and a more diffusely arranged sketch for the figures (Private Collection).

The mood of merrymaking, reminiscent, as suggested by John Barrell, of John Gay's *The Shepherd's Week*, implies that the peasants may be on their way to a harvest celebration rather than returning from work in the fields, even though they have their implements still with them. Certainly they provide more than just a little business for the eye.

To the example of Rubens in the shaft of light coming from the left, and the impressive vista, Gainsborough has added a Claudian mass of trees and delicacy of light. The overall high key and pastel-like effects of bright colour are Gainsborough's own, and make this one of the most imaginative re-creations of country life in his early career. He was to return to the composition again in a late, brooding picture of 1784–5, bought by the Prince of Wales and now in the Art Gallery of Ontario, Toronto.

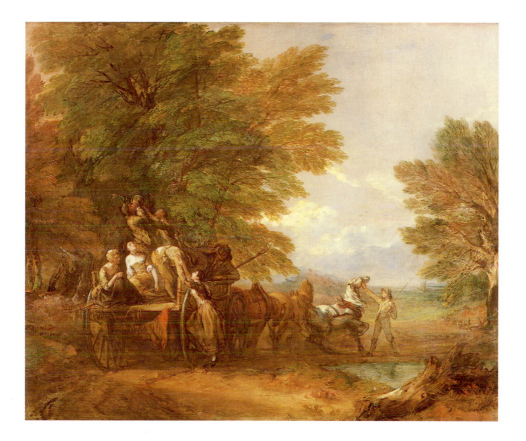

30

A Wooded Landscape with a Waggon in a Glade

c. 1765–7

Watercolour, heightened with white body colour over black chalk; $9\frac{5}{16} \times 12\frac{1}{2}$ in.
(23.7×31.7 cm)

The British Museum, London

At about the same time as he was painting such masterpieces of landscape in oil as *The Harvest Waggon* (Plate 29), and *Peasants Returning from Market* (Plate 32), he was also producing highly finished watercolours with similar themes, based on the countryside around Bath. The stamped gold monogram of the artist at the bottom left suggests that Gainsborough intended this for presentation.

The dazzling display of light and shade and the sophisticated composition show a new control of his draughtsmanship in Bath. He had been impressed by Van Dyck's portraiture, but he has also been influenced by drawings and watercolours then attributed to Van Dyck which we know he admired.

31
A Boy Reclining in a Cart
c. 1767–70

Pen and brown ink with grey and brown washes; 6⁷⁄₁₆ × 8¹¹⁄₁₆ in. (17.6 × 22.1 cm)
The British Museum, London

This is similar to the preceding drawing (Plate 30), but it is a more direct vision of a cart in a landscape, seen earlier on, as it were, in *The Harvest Waggon*'s progress along the lane. The idle, sun-drenched mood seems to be a visual description of Gainsborough's impatience with portraiture: 'being confined *in Harness* to follow the track, whilst others ride in the Waggon, under cover, stretching their Legs in the straw in Ease, and gazing at Green Trees & Blue skies, without half of my *Taste* that's damn'd hard ...' (To William Jackson, Bath, 4 June 1772 (?)).

Lindsay Stainton has commented on the influence of Rembrandt in the pen work and drawing of the figure.

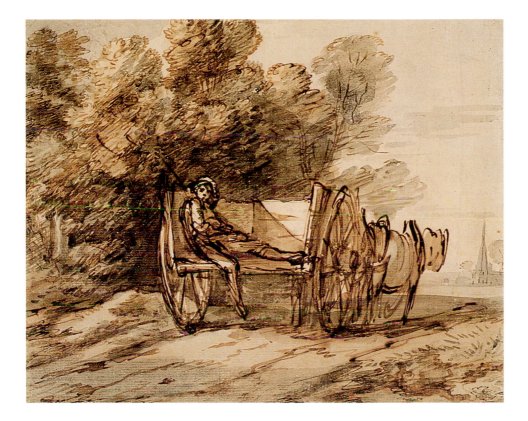

32

Peasants Returning from Market through a Wood

c.1767–8

Oil on canvas; 47¾×67 in. (121.3×170.2 cm)

Toledo Museum of Art, Toledo, Ohio

The painting is one of a group of three commissioned by William, Lord Shelburne, later 1st Marquess of Lansdowne, in the 1760s, 'with a particular injunction that each artist should exert himself to produce his *chef d'œuvre*, as they were intended to lay the *foundation of a school of British landscapes*'. The other two artists were Wilson and Barrett. Works by Deane and Pocock were also later hung with the paintings in the drawing-room at Bowood. Notwithstanding John Briton's description of 1801, the painting was sold from the Lansdowne collection a few years later in 1806.

For such an important commission Gainsborough has created a highly finished work that can be ranked with *The Harvest Waggon* of 1767 (Plate 29). It has the same key and bright colour, but introduces a new subject that he was to return to: the motif of peasants going to or from market. He has made it directly appealing by the principal figure on the white horse, who is a pretty girl, protecting her basket of eggs, and looking directly out of the picture at the spectator while she disdains the attentions of the lad who optimistically doffs his cap.

Unlike contemporary pictures by Greuze of peasant girls and eggs, often broken, there is no moral other than a general, rather melancholy, pastoral mood.

The whole is enclosed by one of his most impressive landscapes to date, with the mass of bright green overarching trees. The cattle at the watering place and the gently winding track remind us of his early interest in Dutch landscapes which is now combined with the vigour of Rubens.

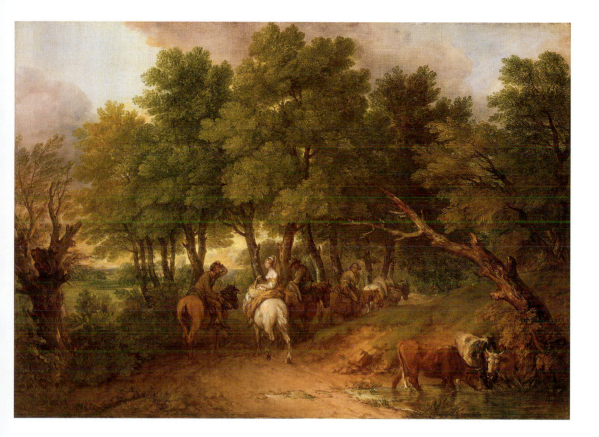

33

Mary, Duchess of Montagu

c. 1768

Oil on canvas; 49½×39½ in. (125.7×100.3 cm)
The Duke of Buccleuch and Queensberry, Bowhill

Mary Montagu (1711–75) married in 1730 George Brudenall (1712–90), 4th Earl of Cardigan, who adopted the name of Montagu on the death of his wife's father in 1749. He was created Duke of Montagu in 1766, and the two formal portraits of husband and wife are recommended as examples of his 'last manner' to Garrick in a letter from Gainsborough of about 1768. The husband proudly wears the ribbon and Order of the Garter while his wife is treated equally formally. They descended to his daughter, Elizabeth, Duchess of Buccleuch, and are still at Bowhill.

He was described by Horace Walpole as 'one of the weakest and most ignorant men living' (1776), and by the *Royal Register*, as having 'a formal coldness of character' which rendered him uncommonly well suited to his post of Governor to the Prince of Wales. His character may well account for the Duchess' reserved and stoical appearance. She looks older than her fifty-seven years, and was to die aged sixty-four. She may have been ill.

Nevertheless, in the quiet dignity and sensitive handling of the beautiful green of her dress set against the rich crimson of the chair and drapery, Gainsborough has finally approached the elegance of Van Dyck. Reynolds is normally known for his psychological studies of old men and women, notably in his insightful portrait of *Anne, Countess of Albemarle*, 1757–9, but whereas with time she has faded somewhat, the colouring of Gainsborough's equally successful portrait has remained stable. To his feeling for the stuff of fabric, for example in the shot silk of her sleeves, Gainsborough has added a nobility of pose and mastery of linear design which he has clearly absorbed from Van Dyck's aristocratic lesson. One of his own freely painted landscapes is on the wall behind.

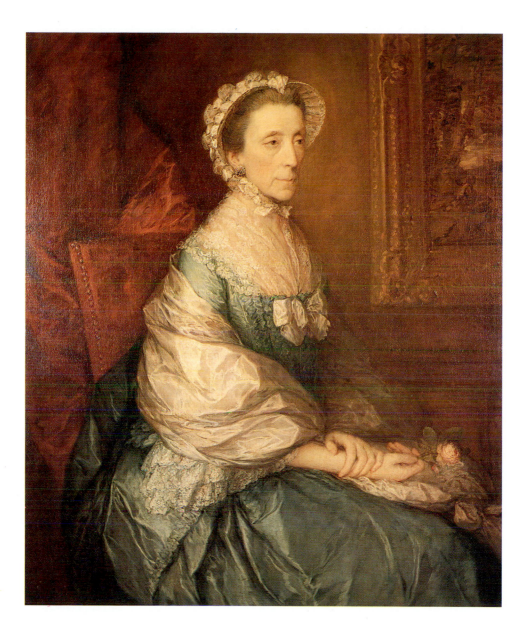

34

River Landscape near King's Bromley, Staffs., with Figures in a Boat

c. 1768–70

Oil on canvas; 47×66⅛ in. (119.4×168.1 cm)

Philadelphia Museum of Art

The painting seems to combine all the elements from those landscapists of the past whom he admired, notably Claude and Rubens, in the winding river scene, the feathery trees at the water's edge, and the drinking cattle. John Hayes has also convincingly linked its composition with a landscape by Lucas van Uden, still at Stourhead. Gainsborough, however, has creatively united these elements from his study of Old Masters, into what was a rare venture for him, the depiction of a real scene, notwithstanding William Jackson's comment that 'he never chose to paint anything from invention, when he could have the objects themselves'. It represented an actual view near King's Bromley-on-Trent, Staffordshire, with the recognisable tower of All Saints' Church, as it appeared in the eighteenth century, in the distance. It was probably painted for Samuel Newton who lived there, and in whose family it descended, but it is not known when Gainsborough visited Staffordshire.

The figures in the boat with its net seem not so much pleasure bent as merely being ferried across the river. They have been described as Watteauesque, but they seem closer to similar figures and ferry boats often found in the foreground of ideal landscapes of the seventeenth century, particularly ferry boats in paintings by Claude which Gainsborough could have known, if not from the originals, then from the *Liber Veritatis*, or from Claude's own etchings, as he also could have for the motif of the drinking cows. Nevertheless, Gainsborough has transformed them into close cousins of the peasants in his pastorals of *c.* 1767–8 (Plates 29, 32).

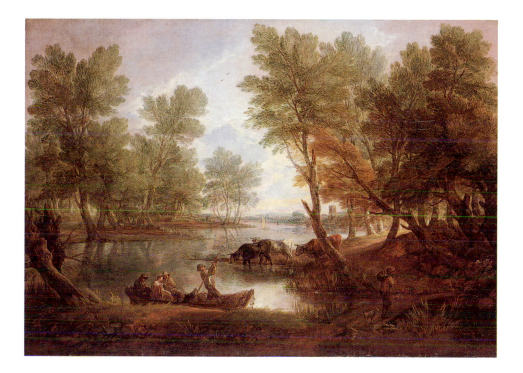

35

Jonathan Buttall, 'The Blue Boy'

c. 1770

Oil on canvas; 70×48 in. (177.8×121.9 cm)

Henry E. Huntington Library and Art Gallery, San Marino, California

This is one of Gainsborough's most celebrated works, but probably known to most people from the many popular reproductions, rather than from the original which has remained in California since 1921. X-rays have revealed that the portrait was painted on a discarded canvas, so that it may well have been done for pleasure instead of on commission. The sitter was the son of a Soho ironmonger who owned property in Ipswich, and Jonathan was to become a close friend of the artist, probably because of their shared musical tastes.

The wearing of a 'Van Dyck' costume by men and women was quite common from *c.* 1730 onwards for masquerades, portraits, and everyday dress, and Gainsborough kept such a costume for those sitters who wished to be portrayed in it. There were not actually very many, mostly boys or young men, with the notable addition of *The Hon. Mrs Thomas Graham* (Plate 46). Gainsborough himself was not entirely happy about fancy dress which he thought detracted from the likenesses, and about which he had written to the Earl of Dartmouth in 1771, the year after he had probably exhibited this portrait at the Royal Academy.

To the costume, influenced by Van Dyck's paintings, from double portraits of *George and Francis Villiers* (Windsor Castle) and *George Digby, 2nd Earl of Bristol and William Russell, 1st Duke of Bedford* (Earl Spencer), he has also added a forthright version of these Van Dyck poses, with one hand elegantly on his hip, and the other holding the large feathered hat down at his side but looking boldly out at the spectator. The landscape with its diagonal movement adds to the dramatic effect which, of course, is increased by the choice of the dominant blue for the costume. Whether Gainsborough did so deliberately to thwart academic tradition or to make a splash at the Academy exhibition is not known.

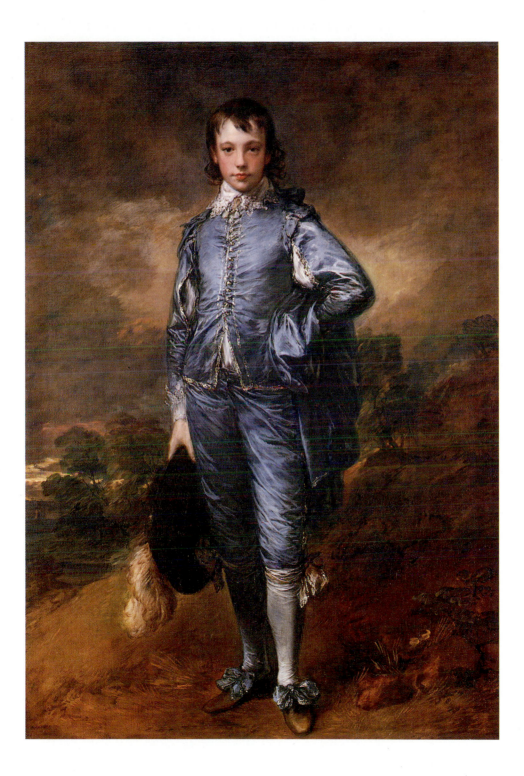

36

A Village Scene with Horsemen and Travellers

c. 1770

Watercolour over black chalk; 9¼×12⅞ in. (23.5×32.7 cm)
Yale Center for British Art, New Haven

Gainsborough's landscapes of pastoral village scenes were visions of 'quietness and ease', as he described them. They are rarely accurate renderings of the darker side of village life, or, indeed, of any actual village. There are villagers and cattle moving through, or about, in plausible action 'to create a little business for the Eye to be drawn from the Trees in order to return to them with more glee', as he saw them. These scenes became an obsession during his period in Bath before he returned to London in 1774. They are likely to be based on paintings or prints he had seen by Netherlandish artists such as Teniers. The church towers have a particular configuration like 'the little Dutch spire' he had seen in pictures by Bout and Boudewijns, with a distant memory of spires he had known since childhood in East Anglia, such as Great Cornard (see also the following Plate 37).

He was also obsessed with complicated techniques of draughtsmanship which blur the conventional distinctions between watercolours, drawings, and paintings. One such experimental method of mixing oil, chalk, white heightening, and varnish he described to his friend, William Jackson, in a letter of 1773, in which he enjoined his friend 'never to impart my secret to any one living . . .'. His insistence on 'Effects' indicates that the subtleties of light and dark, which he often created by candlelight, were meant to be appreciated by the spectator. This example is a *chiaroscuro* imitation of seventeenth-century drawings where the white is the white of the paper, with wash laid over chalk.

37

Wooded Village Scene with Drovers and Cattle

c. 1771–2

Oil and mixed media on paper laid on canvas; 24½×29⅜ in. (62.3×74.5 cm)
Yale Center for British Art, New Haven

This is another example (see preceding Plate 36) of Gainsborough's experimental methods which he applied to his generalised scenes of rural life. Although it is on the scale of a painting, it was drawn with chalk on varnished paper which he has exploited where it shows through in the sky. The strokes of the brush imitate the effect of pastel, and the flickering white touches show his paintings becoming like drawings and *vice versa*.

His personal mixture of drawing and painting, using watercolour, chalk, and oil, and his blurring of the distinction between sketch and finished painting look forward to the nineteenth century, as does his personal romantic vision. His nostalgic views of village scenes, drawn as much from art as nature, are equally very much part of the eighteenth century, enshrining in visual images the rococo tradition of the virtuoso performance, in which his love of art and music have been combined.

38

Study of a Music Party

Early 1770s

Red chalk and stump; 9½×12¾ ins. (24.1×32.4 cm)

The British Museum, London

Not all of Gainsborough's life in Bath was spent relentlessly studying Old Masters in pursuit of a grand style of landscape painting, or the endless depiction of faces for profit. His first exhibited Bath portrait had been of Mrs Thicknesse (Plate 19), whose viol da gamba he had coveted and which was later to be the cause of an argument between him and her husband.

He loved music and musicians, as his portraits of Abel (Plate 45) and Fischer (Plate 50) demonstrate, and this intimate study in red chalk records what must have been a frequent part of his life; indeed the musical influence gives some understanding of his art, as his letters to William Jackson testify.

It has been proposed by Lindsay Stainton that this hasty sketch of an informal musical evening possibly represents the Linley family who lived in Bath. The violinist may be the prodigy Thomas Linley (1756–78), and the singer behind him, his sister, Elizabeth (1754–92), who married the playwright Richard Brinsley Sheridan (Plate 67). They seem to have paused to discuss, rather than play – with the pet under the harpsichord in full attention, – 'the nature of Modulation and the introduction of flats and sharps', which Gainsborough in a letter to Jackson felt he had begun to understand.

39
Sir Benjamin Truman

c. 1770–4
Oil on canvas; 93×58½ in. (236.3×148.6 cm)
The Tate Gallery, London

This sturdy image of the brewer (1711–80), then aged about sixty, descended in the Black Eagle Brewery in Brick Lane, Spitalfields, which still bears his father's name. When the firm was acquired by Maxwell Joseph, the painting was eventually sold to the Tate Gallery in 1978. Without quite the variety of poses that Reynolds manipulated, Gainsborough could, nevertheless, strike to the heart of a sitter to whom he was obviously sympathetic.

Truman is shown as a country gent, very similar to Lord Kilmorey (Tate Gallery), with walking stick grasped firmly in one hand, and his hat, which reveals the maker's name, in the other, as John Hayes has pointed out. This sort of particularity would not have been allowable for Reynolds' more generalised poses.

Truman was knighted, in the tradition of English brewers, for helping to raise loans and general services to the Tory Party on the accession of George III in 1760. His country estate, 'Popes' at Hertingfordbury, has been hinted at by Gainsborough in the background. In these days of heritage parks, and pubs advertising their old 'real' ales, no more genuine image of John Bull and the presumed benefits of beer over gin, as Hogarth had illustrated, exists.

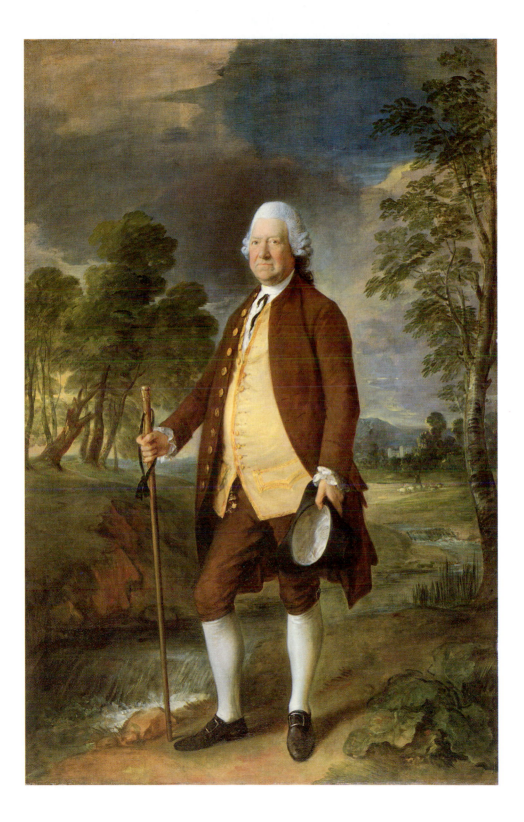

40

Sir William Johnstone-Pulteney, later Fifth Baronet

c. 1772

Oil on canvas; 93½×59 in. (237.5×149.8 cm)

Yale Center for British Art, New Haven

William Johnstone (1729–1805), of Westerhall, Dumfries, took the name Pulteney in 1767 when his wife, Frances, succeeded to the Pulteney estates of the Earl of Bath. He was to become 5th Baronet in 1794. He had, according to a contemporary, 'a good deal of vivacity and humour but has studied them away'. With his wife's inheritance, he was transformed from a poor lawyer to one of the richest men in England, who, nevertheless, retained his frugal habits.

He was responsible for the Pulteney Bridge in Bath and the development of the local estate, and when he became an MP he was active for a peaceable solution to the American War of Independence, even attempting to negotiate with Benjamin Franklin in Paris in 1778. He foresaw that an independent America 'would soon rival Europe in arts as well as grandeur, and their power in particular would rear itself on the decay of ours'. The fact that he held immense estates around New York of almost one million acres may have been relevant to his political stance.

Gainsborough has caught some of the characteristics of the sitter in the gravity of pose and expression, and sombreness of tone, as he was described in his obituary of 1805: 'Under a forbidding exterior and still more neglected or almost threadbare dress which he usually wore, he manifested strong sense, a masculine understanding, and very independent as well as very upright principles of action.'

The portrait was probably exhibited at the Academy in 1772, after further sittings which Gainsborough had asked for, to 'finish a little higher to great advantage ... of one more little sitting of about half an hour ... I am fired by the thoughts of Mrs. Pulteney's giving me leave to send you to the Royal Exhibition, and making a good Portrait of you ... '.

His vivacity of paint enlivens the whole image and its landscape background, but it has now faded somewhat, particularly in the blue of the sky, which has been revealed by a strip at the right, previously hidden under the old frame.

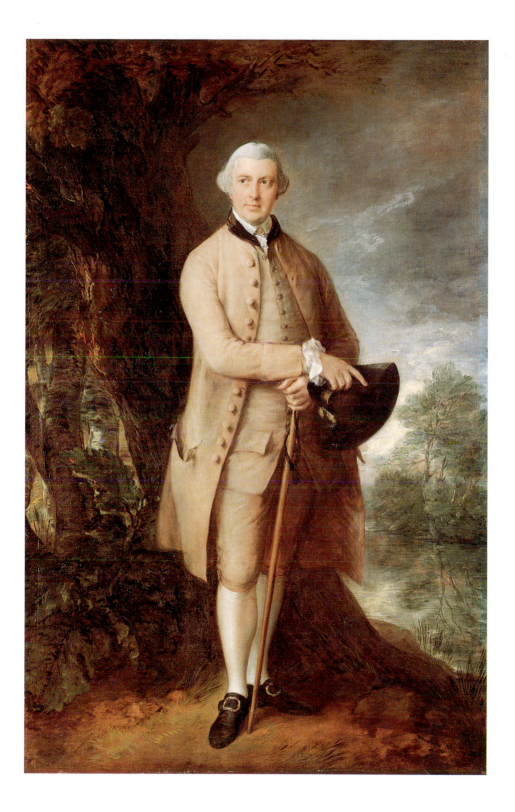

41

Peasants Going to Market

1773

Oil on canvas; 48×58 in. (121.9×147.3 cm)
Royal Holloway College, Egham, Surrey

The opportunities provided for Gainsborough to study Old Masters within reach of Bath have already been mentioned. There were not only portraits by Van Dyck, for example, but landscapes by Claude, Rubens, and Dutch masters, such as Cuyp, who all gave Gainsborough an historical lesson in the creation of landscapes on an heroic scale by the unifying effects of light. During the 1760s he had already initiated the theme of peasants going to or from market, and the present example is one further variation. A drawing in a private collection which may be related to it has been dated as late as *c.* 1780–3.

As has been pointed out by Dillian Gordon, the example of Cuyp, the Dordrecht master of golden light, is the inspiration for the flood of light behind the riders, as it was to be later for Turner in his homage to Cuyp in his *Dort*, but whereas Cuyp's figures tend to be stationary, and their relationships enigmatic, Gainsborough's figures here are full of sentimental interactions. There is a hint of courtship in the eye contact between the two principal riders, already seen in the Toledo picture (Plate 32), and there is a mother in the left foreground with two children, apparently blissfully asleep in a swamp.

These variations on a theme are clearly not realistic, but idealised, as Hazlitt later remarked. This particular example must have hit a spot with Gainsborough's banker, Henry Hoare, who paid 80 guineas for it on 6 July 1773, a large sum for a contemporary landscape. It hung as an overmantel at Stourhead until its sale in 1883.

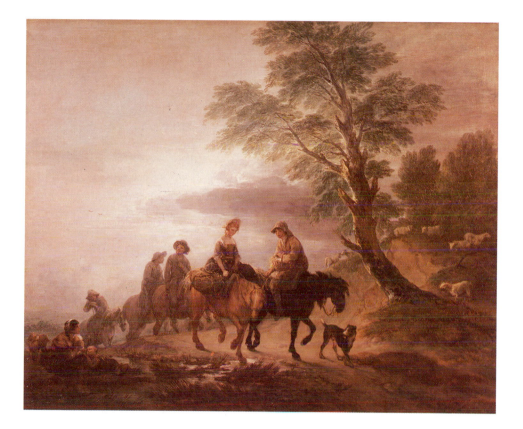

42

A Landscape with Cattle and Figures by a Stream

c. 1772–4
Signed lower right with monogram: 'T.G.'
Oil on canvas; 47¼×57¼ in. (120.0×145.4 cm)
Yale Center for British Art, New Haven

This is one of a series of impressive landscapes which Gainsborough painted at Bath. No landscape artist can have failed to be impressed by the paintings of Claude, which Gainsborough had seen: at Corsham, *The Temple of Bacchus*; at Longford Castle, engraved by William Woollett and published by Boydell in 1772, as *Roman Edifices in Ruins: The Allegorical Evening of the Empire*; and possibly *Mercury and Battus*, at Holker. These may well have provided him with actual motifs, but there are also a number of Claudian details. For example, the bridge in the middle distance, the mountain on the horizon, the distant town, the mass of trees at the right, balanced at the left by a hillside with a ruin, the flash of light on the foreground stream, the herds-boy leaning on a stick, the carefully placed cattle and goat, the herd of sheep crossing the bridge, the whole enveloped in an evening light from the right which sweeps across the landscape, catches the haunches of the cattle, and silhouettes the mass of trees.

The blues of the sky, and the green of the leaves have, perhaps, faded somewhat, and with the red-brown ground showing through, and a certain thinning from past cleanings, the yellow effect of the golden glow is over-emphasised. There is cracking at the left which may have been caused by changes, and his use of very wet, thin paint. Nevertheless, the rosy glow which catches these classical ruins at the left, the impressionist touches of pure pinks, blues, and reds, the strokes of the brush, like penwork, which describe the rushes and the trees, and the peasants in the shadow at the right are Gainsborough's own contribution to a pastoral twilight's last gleaming.

He may equally have been influenced by Claude's drawing style in the way he has painted the feathery trees, the flicks and marks which suggest textures, such as the wool of the sheep, and the dramatic opposition of light and dark. He may also have been acquainted with Claude's inimitable method of squaring in diagonals which, perhaps, accounts for the way in which all the details are carefully placed on a similar geometric structure. This never detracts, however, from the impro-vised mood of the painting, with an instinctive use of the Golden Section and the unifying 'S' curve of the design. A careful drawing of the composition is recorded, which concentrates on the generalised masses and highlights.

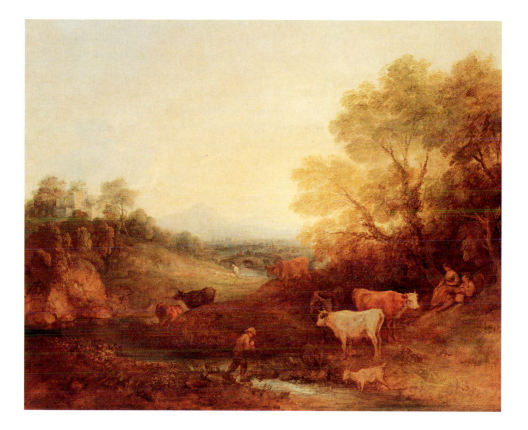

43

A Rocky Valley with Two Women and a Child, a Shepherd and Sheep with a Distant Village and Mountains

c. 1773–4

Oil on canvas; 48×58¾ in. (121.9×149.2 cm)

Yale Center for British Art, New Haven

This magisterial vista was created either just before he left Bath for London, or immediately after he arrived there in November 1774, and is another example of his study of Old Masters, which has been previously mentioned. If the preceding plate (Plate 42) was evocative of Claude, then the present picture is closer to Gaspard Dughet, and the ultimate influence of Titian, with its rocky landscape and mountainous distance. We are also reminded of Gainsborough's habit of composing landscapes on his painting table, and there is more than a hint of broccoli and coal in the trees and rocks at the right.

The overall effect of cool brightness seems to suggest an early morning scene, with the light coming from the left and hitting the distant villages. It is more colourful than the preceding landscape, and there are myriad touches of pure yellows, blues, reds, and greens which give great variety to the surface. Reynolds described them as 'those odd scratches and marks which ... at a certain distance assume form'.

We know how seriously Gainsborough took the hanging of his pictures, and in 1773 he had quarrelled with the Royal Academy, of which he had been a Founder Member in 1768, not to exhibit there again until 1777. This landscape is as dramatic at a distance, through his use of contrasts of light and dark, achieved by translucent dark glazes, as it is from near to, when his rapid brushwork becomes apparent. The flock of sheep emerging out of the dark centre of the painting gives a touch of cool light to contrast with the warmth of the fire in the quarry in the mid-distance. The motif of the woman pointing he may have taken from Claude, while the mother and child are to appear again in a series of landscapes devoted to scenes around a cottage doorway (Plates 51, 55, and 75).

116

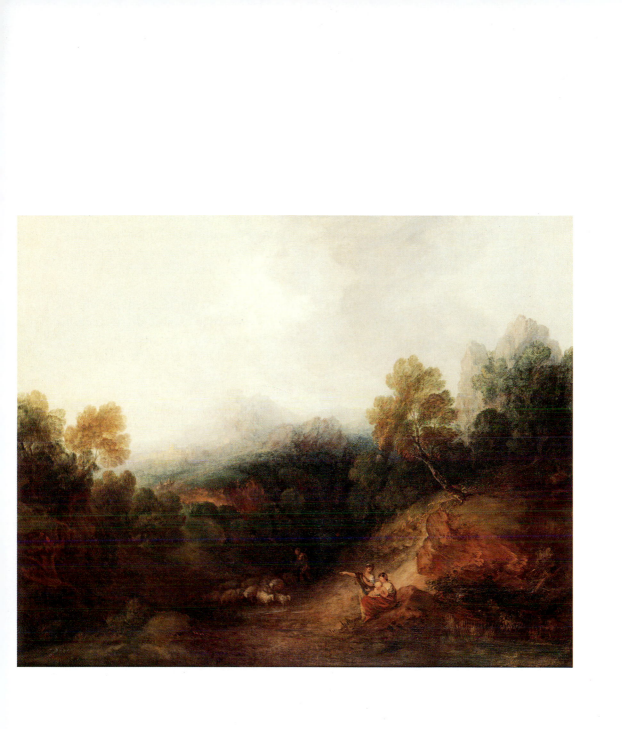

44
The Watering Place

1777

Oil on canvas; 58×71 in. (147.3×180.3 cm)

The National Gallery, London

In this large, impressive work we see the culmination of Gainsborough's eclectic phase in his landscape development. In Suffolk he had imitated Dutch 'landskips'; in Bath and on his return to London, he had taken on a series of confrontations with the art of the past, as Turner was later to do. From henceforth, his landscape paintings were to be entirely original.

Contemporary critics, of whom Horace Walpole was one, realised this when it was exhibited at the Royal Academy in 1777, his first exhibit there since his quarrel with the Academy in 1773 (see also following two portraits): 'In the style of Rubens, & by far the finest Landscape ever painted in England, & equal to the great masters.' It was as if Gainsborough had to show that landscape could be the equal of historical painting, as Reynolds had realised with portraiture.

It was a composition in which he had invested much study. A drawing and soft ground etching exist where Gainsborough experimented with grand effects of *chiaroscuro*. The influence of Rubens is dominant, whose *Watering Place* Gainsborough had advised Garrick to see in 1768, when it was in the collection of the Duke of Montagu (see Plate 33). The massive density of the trees and the baroque sense of distance towards the mountainous horizon are part of this influence.

The fall of light, with translucent shadows and flickering highlights, however, has romantic overtones as it catches the pointing figure at the left, borrowed from Claude, while the brushwork of the foreground is Gainsborough's own. A contemporary Italian artist saw its originality: 'The pencilling [i.e. brushwork] is so new, so original, that I cannot find words to convey any idea of it ... '

The picture was badly hung, and clearly needed to be viewed from near and far, as Constable knew when his own works were exhibited at the Paris Salon of 1824. Its originality, perhaps, prevented its sale during Gainsborough's lifetime, but its debt to the Old Masters may have been the reason that Charles Long, later Lord Farnborough, a Director of the British Institution, bought it in 1797, and bequeathed it to the newly established National Gallery in 1827.

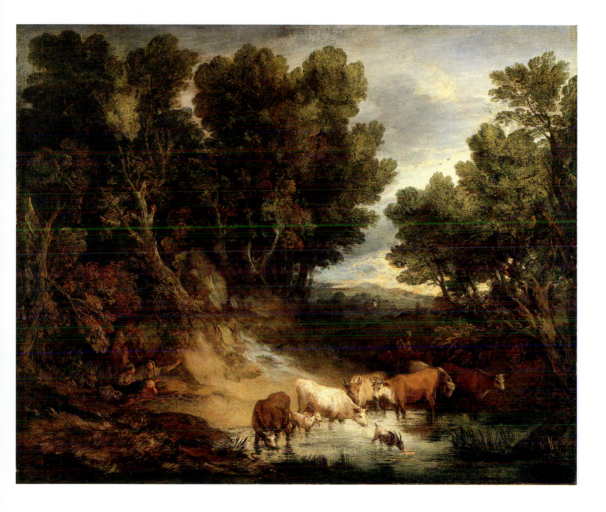

45

Carl Friedrich Abel

1777

Oil on canvas; 88×58 in. (223.5×147.3 cm)

Henry E. Huntington Library and Art Gallery, San Marino, California

Carl Friedrich Abel (1725–87) was one of Gainsborough's closest friends. He was a celebrated virtuoso on the viol da gamba and composer, who came to England in 1759 after performing with J. S. Bach in Dresden. He was to live and perform with J. C. Bach, who was also painted by Gainsborough. The artist had exchanged two painted landscapes (one of which is now at Bowood) for one of his instruments, and Abel's walls, in turn, were covered with drawings by Gainsborough. Gainsborough was to buy one of his finest instruments at the sale after his death in 1787.

An earlier portrait of the 1760s by Gainsborough, now lost, but for which a fine chalk study is in the National Portrait Gallery, London, shows Abel looking up in the act of playing, but here he is shown having laid down his instrument to pause in the act of composing. Such images of the writer or artist inspired by his muse, or interrupted by business, had a long history, going back to images of St John on Patmos, but the apotheosis of the creative individual seems to be particularly common in the eighteenth century. Roubiliac's sculpture of *Handel* at Vauxhall would have been well known to Gainsborough and Van Loo's portrait of *Diderot*, which may have been known, is quite close to Gainsborough's example. Gainsborough's version, however, is very direct, with the force of light creating the flash of inspiration, and it is so immediate that we worry that the viol da gamba might slide off Abel's knee.

Some measure of Gainsborough's depth of feeling for his friend can be gauged from the moving letter which he wrote to Bate-Dudley after Abel's death:

> Poor Abel died about one o'clock today, without pain, after three days' sleep. Your regret, I am sure, will follow this loss. We love a genius for what he leaves and we mourn him for what he takes away. If Abel was not so great a man as Handel it was because caprice had ruined music before he ever took up the pen. For my part, I shall never cease looking up to heaven – the little while I have to stay behind – in hopes of getting one more glance of the man I loved from the moment I heard him touch the string. Poor Abel! – 'tis not a week since we were gay together, and that he wrote the sweetest air I have in my collection of his happiest thoughts. My heart is too full to say more! (20 June 1787)

Gainsborough's portrait remains as a deeply serious and everlasting tribute to their friendship, for all its air of spontaneity, and was one of a spectacular group of pictures with which he marked his return to the Royal Academy in 1777.

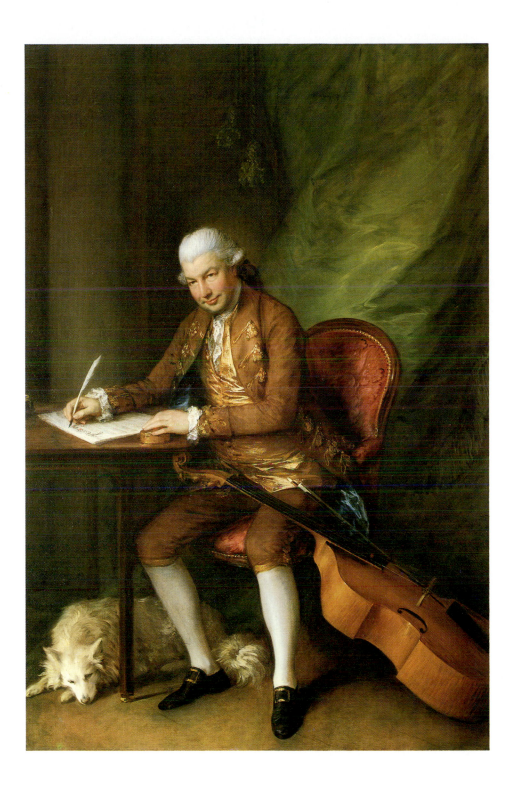

46

The Hon. Mrs Thomas Graham

1777

Oil on canvas; 93½×60¾ in. (237.5×154.3 cm)
The National Gallery of Scotland, Edinburgh

His most outstanding exhibit at the Royal Academy of 1777 was the portrait of *The Hon. Mrs Thomas Graham* (1757–92) (See preceding Plates 44 and 45 for two other exhibits; the others were a blunt portrait of *Viscount Gage*, still at Firle Place, and full-lengths of the *Duke and Duchess of Cumberland* (Plate 60)). Gainsborough had returned triumphantly after four years' absence, and clearly wanted to make his presence felt. Reynolds was to exhibit thirteen works including *Lady Bamfylde* (Tate Gallery), a similar essay in the manner of Van Dyck, and had exhibited his famous portraits of the *Duchess of Devonshire* (Huntington Art Gallery) and *Mrs Lloyd* in 1776. *Mrs Graham* is a *tour de force* in the manner of Van Dyck (see '*The Blue Boy*', Plate 35), both in the extravagant masquerade costume, and in the grandiose pose. Her left hand, with elegantly displayed fingers, grasps the fluttering drapery, while her right arm falls gracefully to hold the feather.

Again, however, it would never be mistaken for a Van Dyck. It is of its time, and yet looks forward to Edwardian extravagances. The baroque column is enormous, with leaves tumbling over it. Gainsborough has also exploited what was to become a fashion photographer's trick of elongating the body to make it more elegant, a device initiated by Titian and Van Dyck to achieve maximum flattery of the sitter. Even the mannerist norm of Michelangelo's twenty-seven nose lengths to the length of the body, as he described it, has been much exceeded to over thirty, and exaggerated by the tilt of her high feathered hat and elaborate coiffeur.

Mary, second daughter of the 9th Earl of Cathcart, then aged seventeen, married Thomas Graham of Balgowan, later Lord Lynedoch, in 1774. After her death in 1792, Graham is said to have been so heartbroken that he sent the picture away for storage, where it remained until after his death aged ninety-five in 1843. It was bequeathed to the National Gallery of Scotland in 1859.

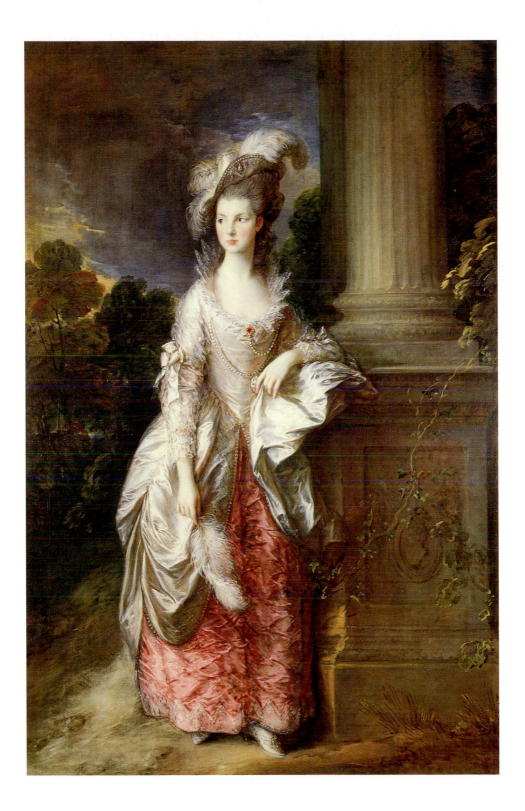

47

Grace Dalrymple, Mrs John Elliott

1778

Oil on canvas; 91½×60½ in. (234.9×153.6 cm)

Metropolitan Museum of Art, New York

If the preceding portrait can be seen as an aristocratic invention for a young girl, recently married, then this image, exhibited at the Royal Academy in the following year, reveals Gainsborough's ability to flatter members of the *demi-monde*, of which Reynolds, surprisingly enough, had also produced notable examples, for instance, *Mrs Fisher*, *Nelly O'Brien*, and *Mrs Abington*.

Grace Dalrymple (1758–1823) married John Elliott, later Sir John Elliott, a notable physician eighteen years her senior, in 1771. She was divorced in 1774 for adultery with Lord Valentia, later Earl of Mountnorris, and subsequently became the mistress of Lord Cholmondely, the Prince of Wales, and, in France, the Duc de Chartres, to name but three. She was known as 'Dally' or 'Dolly the Tall', because of her height.

Here she floats across the canvas with even more elongated proportions than the previous portrait, in a golden yellow dress, but with, perhaps, more truth to her real appearance. She clutches her drapery to her bosom, as Lely might have painted it, and with not much less exposure, but delicately holds the end of the silk with an arm lengthened beyond belief.

Gainsborough's version of Van Dyck's movement into space could sometimes teeter on the edge of caricature, but here his version of the truth, as we can imagine it, is exactly right for its evocation of courtly sensuousness. When the portrait was exhibited at the Academy, her colouring was slyly criticised by a journalist, who compared it to what was described in Sheridan's *School for Scandal*, the smash hit of the previous year, as 'coming in the morning and going away at night', but the elegant pose and fluttering eyelids still evoke an age which Gainsborough and his friend, Sheridan, so well understood. A head and shoulders by Gainsborough of *c.* 1782, probably painted after the birth of her daughter, seems to have been paid for by the Prince of Wales, who may have been the father, but the daughter was looked after by Lord Cholmondely, who seems to have paid for the full-length.

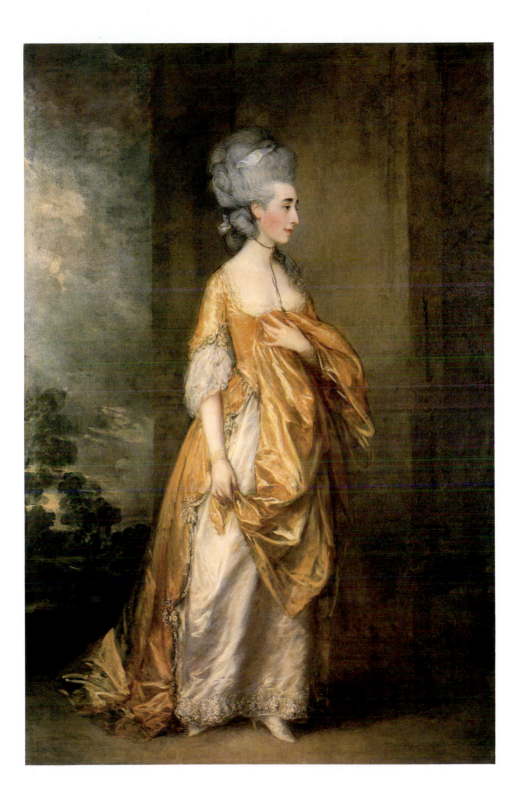

48
Philip James de Loutherbourg
1778

Oil on canvas; 30⅛×24¾ in. (76.5×62.9 cm)
Governors of Dulwich Picture Gallery, London

At the same time as Gainsborough was painting elaborate full-lengths of fashionable sitters (see preceding examples, Plates 46, 47), and sometimes of his friends (Plates 45, 50), he also painted more intimate studies of musicians and artists he knew well. These small studies may have been painted as much out of friendship as on commission. De Loutherbourg also painted a sketch of Gainsborough.

Philip James de Loutherbourg (1740–1812) had only arrived in England from France in 1771, but through his theatrical connections, designing stage scenery for Garrick, he became a friend of Gainsborough, who was most impressed by his 'transparent shades' in the theatre, known as the *Eidophusikon*, first introduced in 1781 (see Plate 55).

Gainsborough had painted J. C. Bach very directly, but in this hastily painted sketch he has introduced an air of inspiration into the tilt of the head, as if they were both on the run in their professions. Gainsborough may have felt a kindred spirit in de Loutherbourg's highly strung temperament and his improvisatory ability, which picked up contemporary currents in art, not without a sense of humour, that Gainsborough would well have appreciated.

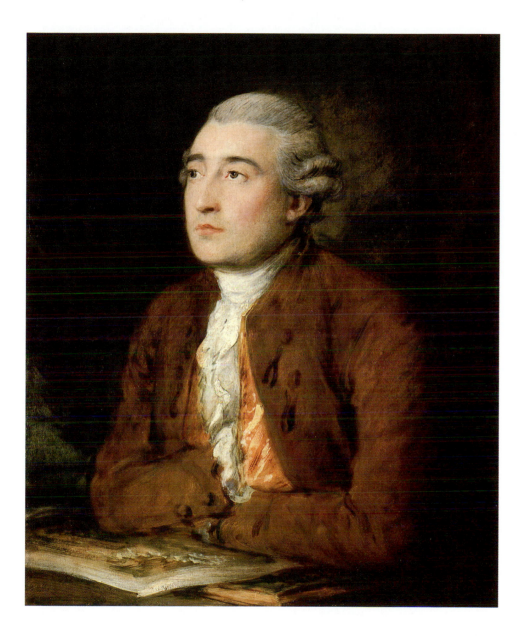

49

The Reverend Henry Bate, later Sir Henry Bate-Dudley

1780

Oil on canvas; 88 × 59 in. (223.5 × 149.9 cm)

The Tate Gallery

The Reverend Henry Bate (1745–1824) had been ordained as a clergyman, but before the age of thirty he had founded the *Morning Post* in 1772, a newspaper of which he was proprietor and editor, until he left it to found the *Morning Herald* in 1780. He assumed the name Bate-Dudley in 1784 and was created a Baronet in 1813.

Bate became Gainsborough's most famous champion, and his writings in support of the artist during the 1770s and 1780s, and, indeed, his obituary of 4 August 1788 in the *Morning Herald*, give us the closest view of Gainsborough's intentions. Many of his journalistic comments about the bad hanging of Gainsborough's pictures seem to come from Gainsborough's own mouth. Yet the portrait of Bate remains something of an enigma.

Clearly, Bate was rich, aristocratic, but yet pugnacious – he had fought a duel on behalf of his opinions in the press, and was known as the 'Fighting Parson' in the gallant defence of his wife's sister at Vauxhall. Equally, he was the friend of the Prince of Wales, a musician on the violincello, librettist of *The Flitch of Bacon*, and dramatist, and remained a clergyman, eventually becoming a prebendary of Ely Cathedral. Perhaps no one could have summed up his character completely in any portrait. Gainsborough, who by 1780 was much beholden to him for his comments, shows him merely as an aristocratic and hospitable landowner at Bradwell, Essex, where the picture remained until sold in 1887. Only, perhaps, in the arrogant tilt of the head does Gainsborough express something of Bate's complicated character (see Plate 70 for the portrait of his wife).

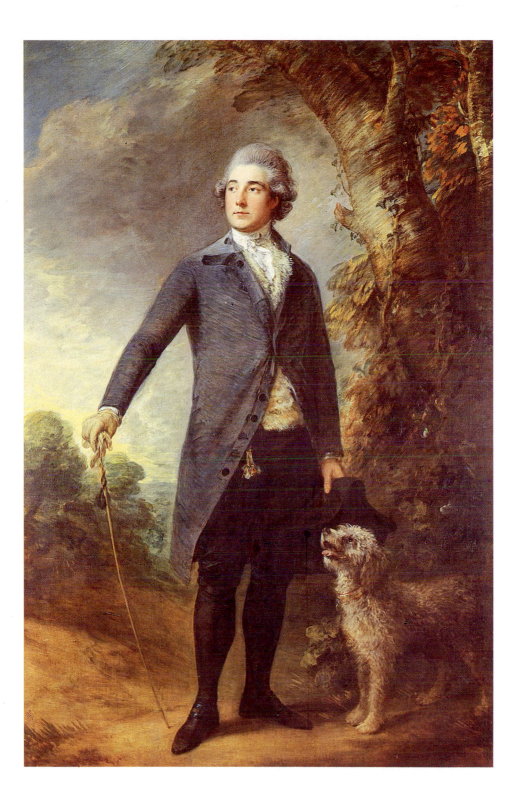

50
Johann Christian Fischer
1780
Oil on canvas; 90×59¼ in. (228.6×150.5 cm)
Her Majesty The Queen

The painting is comparable to Gainsborough's portrait of *Carl Friedrich Abel* (Plate 45), that is, of a musician he knew well. Given the circumstances of their relationship, it is a noble and sensitive study of an inspirational moment. He had agonised over such a subject, with a portrait of *Garrick Contemplating Shakespeare*, which he described in a letter of 1768 to Garrick: 'an immediate Ray darting down upon his Eye turn'd up for the purpose; but G. damn it I can make nothing of my Ideas there has been such a fall of rain from the same quarter . . . '.

This full-length of 1780 is much more successful. Gainsborough probably did not know of Duplessis' similar portrait of *Gluck Composing*, 1775 (Vienna). Fischer (1733–1800) was in the court band at Dresden and then in the service of Frederick the Great. He arrived in England in 1768, achieving fame as an oboist and composer, and became Musician to Queen Charlotte in 1780. Mozart was to write variations on one of his Minuets (K. 179). Fischer's oboe is seen resting on his Merlin harpsichord-cum-piano, while, in a striking crimson coat, he leans elegantly on the keyboard in the act of composing, surrounded by manuscripts.

Gainsborough had been much perturbed by finding that his elder daughter, Mary, was conducting a clandestine affair with Fischer; as he wrote to his sister, Mary Gibbon, in 1775:

> I have never suffered that worthy Gentleman ever to be in their company since I came to London; and behold while I had my eye upon Peggy, the other Slyboots, I suppose has all along been the Object. Oh, d—n him, he must take care how he trips me off the foot of all happiness.

His daughter married Fischer to her father's disapproval, but grudging consent, in February 1780. Gainsborough wrote to his sister, Mary, with some attempt at fairness:

> I can't say I have any reason to doubt the man's honesty or goodness of heart, as I never heard anyone speak anything amiss of him; and as to his oddities and temper, she must learn to like as she likes his person, for nothing can be altered now. I pray God she may be happy with him and have her health.

The marriage did not last long, and it is a remarkable tribute to Gainsborough's objectivity as a portraitist that he could produce such a sensitive study of this shy, eccentric, yet talented sitter. Perhaps the sittings took place before the marriage, as the portrait was exhibited at the Royal Academy the same year, 1780. It may have been equally their mutual love of music which carried Gainsborough along.

130

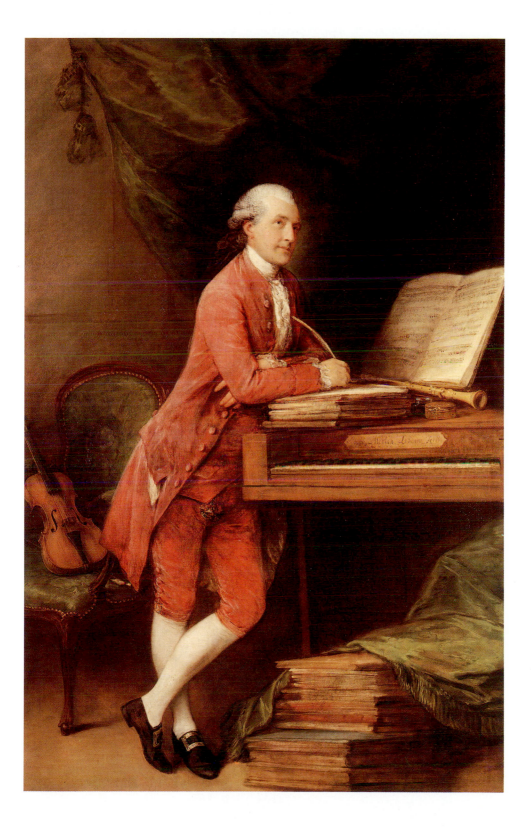

51

The Cottage Door

1780

Oil on canvas; 58×47 in. (147.3×119.4 cm)

Henry E. Huntington Library and Art Gallery, San Marino, California

The Royal Academy exhibition of 1780 was equally notable for the most important of his 'Cottage Door' scenes. Gainsborough had begun this series in the late 1760s, and he continued to produce variations upon this theme until his death in 1788 (Plate 75). This particular example was much admired by contemporary connoisseurs of landscape, such as Thomas Harvey of Catton House, its first purchaser in 1786, and a subsequent owner, Sir John Leicester, later Lord de Tabley who, like Lord Shelburne before him, wished to give due recognition to the British School.

The true nature of these scenes has been the subject of much recent discussion. When this example was exhibited at the Academy an anonymous critic wrote: 'This beautiful scene where serenity and pleasure dwell in every spot, and the lovely figures composed in the finest rural style, their situation worthy of them, forms a scene of happiness that may truly be called Adam's paradise.' When his *c.* 1778 picture of *The Cottage Door with Children Playing* (Cincinnati) was exhibited, another critic wished he would forgo his portraits 'for the ineffable delight we received from his landscapes'. Early nineteenth-century commentators all recognised the pleasurable artificiality of the scene, one thinking that Gainsborough 'has gone as far as giving it [the female figure] grace and elegance as his subject would permit' (W. H. Pyne, 1818), while J. M. W. Turner thought it expressed 'pure and artless innocence'. Yet none thought it went beyond a true, generalised impression of nature.

The principal figure is certainly intended to be pretty, with a hint of a fashionable hairdo, and her six children, all apparently of similar age, are chubby, contented images of fecundity. The landscape is framed at the right by a dead tree, and at the left by a Claudian confection, with a view over a wooden bridge towards an idealised landscape. The composition is carefully constructed, with one triangle echoing another, within revolving circles of light and shade, with an instinctive use of the Golden Section. It is certainly not artless.

It may not be fair, therefore, to criticise Gainsborough for not painting the rural scene as it really was, with poverty and ugliness, or pandering to a conservative taste that 'whatever is, is right'. To say, on the other hand, that the painting turns its back completely on the real world to enter a literary one of 'retirement and ease', described by his writer friends, the Rev. Graves and William Shenstone, would seem to ignore its visual impact and subtleties. Certainly his friend, Bate, saw in the last of this series a source of visual enjoyment, as if the enchantments of poetry were compressed 'to the glance of the eye'.

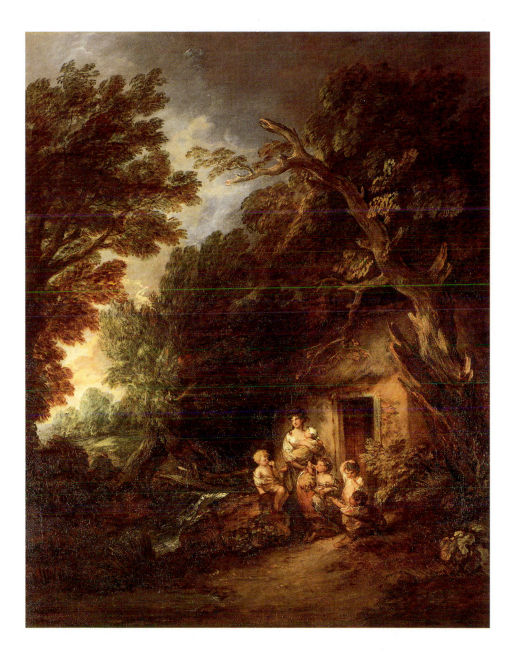

52

Mrs Mary Robinson, 'Perdita'

1781

Oil on canvas; 90×60¼ in. (228.6×153.0 cm)

The Wallace Collection, London

Our ideas of what a portraitist should represent have been forever complicated by the requirements of a likeness on the part of the sitter which has to be balanced by the artist's own conception. Gainsborough was forever complaining about the journeyman aspect of his role. For some portraits, however, from the Romantic age, facts hardly matter, and we think we understand an age by the artist's own vision of it.

With Gainsborough's portrait of *Mrs Robinson, 'Perdita'* these two conflicts are reconciled. Mary Darby (1758–1800) was born at Bristol. She became an actress and married Mr Robinson in 1774. Her first appearance as Juliet in 1776 (aged eighteen) made her fame. The Prince of Wales was much enamoured of her performance as Perdita in 1779, and she became his mistress. She holds in her hand his portrait in miniature by Joseph Meyer, given her by the Prince.

This romantic evocation was painted for the Prince in 1781, but he had already abandoned her by 1782, with a pension of £500 a year. In 1783 she became permanently paralysed after catching a chill, 'in a gallant attempt to save her lover, Col. Banastre Tarleton, later General Sir Banastre Tarleton, from his creditors'. Tarleton, portrayed as a hero of the American War of Independence, and his lover, Mrs Robinson, were painted also by Reynolds, both pictures exhibited in 1782, and he too was painted by Gainsborough. The Prince paid for her portrait by Gainsborough in 1784 (100 guineas), but he must have given it to her, for it appeared in a sale of 1785, to be bought back, and given by the Prince Regent to the 3rd Marquess of Hartford in 1818.

Such a story hardly requires any romantic exaggeration, and Gainsborough's late style was well fitted to provide dramatic *chiaroscuro* around the face, an elegant pose, with toes delicately placed, but holding in her hand a portrait of love that could not be. Her wistful expression seems to emphasise this emotion. The faithful dog and shimmering landscape evoke an immediate moment that Reynolds' more generalised approach rarely attained.

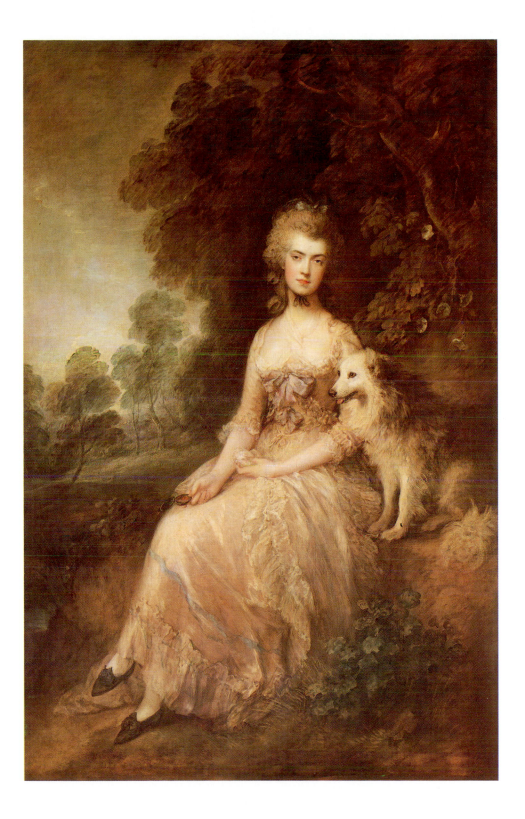

53

Giovanna Baccelli

1782

Oil on canvas; 89¼×58½ in. (226.7×148.6 cm)
The Tate Gallery, London

Gainsborough's connection with the world of music and the theatre may well have been the spur to the creation of this evocative portrait of the famous dancer, Giovanna Baccelli (d. 1801). She danced at the King's Theatre, Haymarket, partly owned by Gainsborough's friend Sheridan, the dramatist, and for which Gainsborough had painted decorative panels of *Music* and *Dancing*. Baccelli is shown in the role and costume of her great success of the 1781–2 season in *Les Amans Surpris*.

She was equally well known as the mistress of the pleasure-loving John Frederick, 3rd Duke of Dorset, with whom she lived at Knole until 1789. Horace Walpole noted that when she danced at the Paris Opera in 1788 she wore around her head the Duke's newly acquired ribbon of the Order of the Garter. She was a popular and attractive figure and when the portrait was exhibited at the Royal Academy in 1782, a contemporary reviewer in the *St James's Chronicle* wrote that:

> This favourite Performer has been the Object of so much deserved Admiration, she is usually seen with so many Advantages of Dress &c that it would be difficult for any Painter to do her Justice in the opinion of her Friends. Mr. Gainsborough, by not aiming at more than Justice, has hardly given a Likeness. The Figure, however, is as the Original, light, airy, and elegant.

He has kept true to his preference for contemporary dress, rather than resorting to what he called the 'unluckiness of fancied dresses taking away Likenesses'. With the elegant dance pose, her coquettish gaze, and the sense of movement and vivacity, she comes closest to the variety of Reynolds' poses as a means of giving expressive character to the sitter. Gainsborough has created an attractive masterpiece, the equal of Reynolds' similar acts of homage to another great lady of the stage, Mrs Abington. Baccelli was one of at least six pictures by Gainsborough once at Knole, and the Duke also commissioned a large number of paintings from Reynolds, Romney, Humphry, Opie, and others.

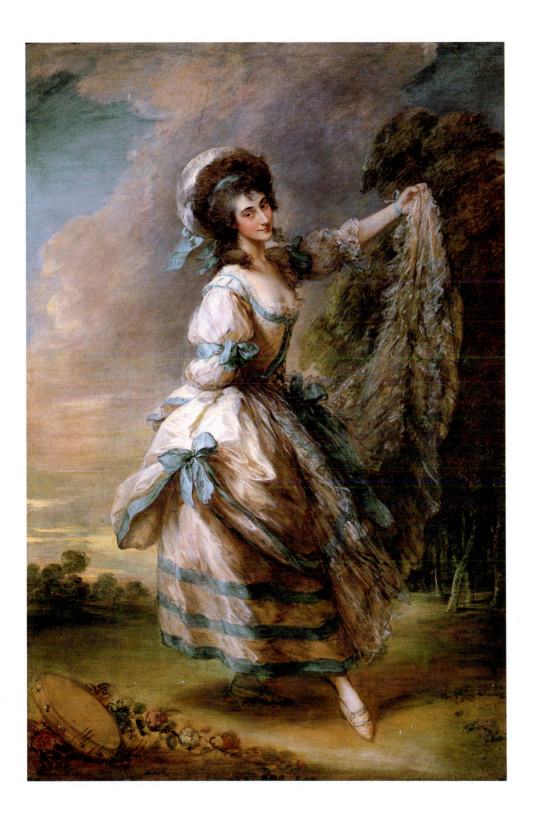

54
Rocky Coast Scene with Fishermen
c. 1781–2
Oil on canvas; 40⅛×50¼ in. (101.9×127.6 cm)
National Gallery of Art, Washington, D.C.

In 1781 Gainsborough exhibited his 'first attempts' at seascapes, as Bate-Dudley described them. He naturally drew on the tradition of Ruisdael and Van Goyen but may well have been equally influenced by the contemporary success of Claude Joseph Vernet (1714–89). There, is however, an immediacy about them which transcends his predecessors' more placid effects. Horace Walpole remarked that they were 'so free and natural one steps back for fear of being splashed!'

These realistic effects are heightened by the pale watery light which dissolves the forms. Doubtless the experience of his transparencies helped. Nevertheless, for all their surface movement, the compositions are carefully constructed, with a dynamic opposition of diagonals, and there exist at least two studies for the present picture. This was also owned by Lord de Tabley when Turner would have seen it.

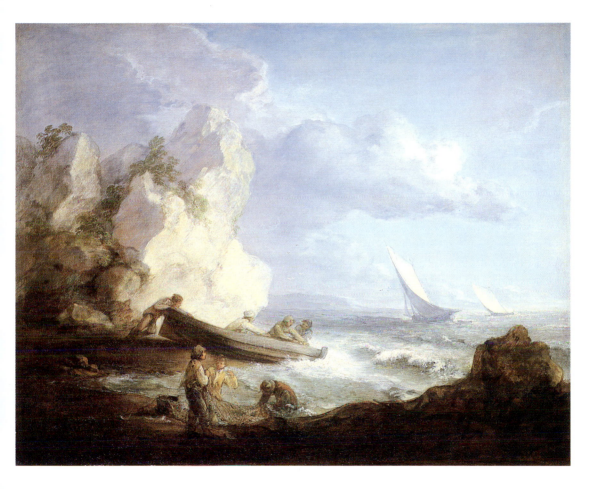

55

Wooded Landscape with Cattle by a Pool and Figures by a Cottage at Evening

1782

Oil on canvas; 47⅞×58⅛ in. (120.4×147.6 cm)
Gainsborough's House, Sudbury, Suffolk

Gainsborough's champion, the Rev. Henry Bate, rightly praised this late, profound landscape when it was exhibited at the Royal Academy in 1782. He emphasised those elements which Gainsborough had brought together in this particular cottage scene, and which differed from others in the series:

> ... It is an evening, at Sun-set, representing a wood land scene, a sequestered cottage, cattle, peasants and their children before the cottage, and a woodman and his dog in the gloomy part of the scene, returning from labour; the whole heightened by a water and sky, that would have done honor to the most brilliant Claude Lorrain!

It owes equally as much to a *Moonlight Landscape* by Rubens, now at the Courtauld Institute, London. Gainsborough's interests in the effects of light had been given new impetus by theatrical effects with transparencies, particularly those of his friend de Loutherbourg's *Eidophusikon*. Gainsborough had been moved to make his own light box, in which painted glass transparencies were seen through a magnifying lens, lit from behind by candlelight filtered through a silk screen. The box and some ten transparencies survive in the Victoria and Albert Museum, and one shows a similar scene.

Gainsborough has attempted to reproduce the flickering effects of *chiaroscuro* which moves over the whole surface, and in one great masterpiece sums up all his ideas of eighteenth-century virtuosity, whereby another variation of his pastoral themes is modulated in mood by brilliant effects of light. It also looks forward to Constable's attempts to make permanent the evanescent effects of nature and still the very droplets of the atmosphere.

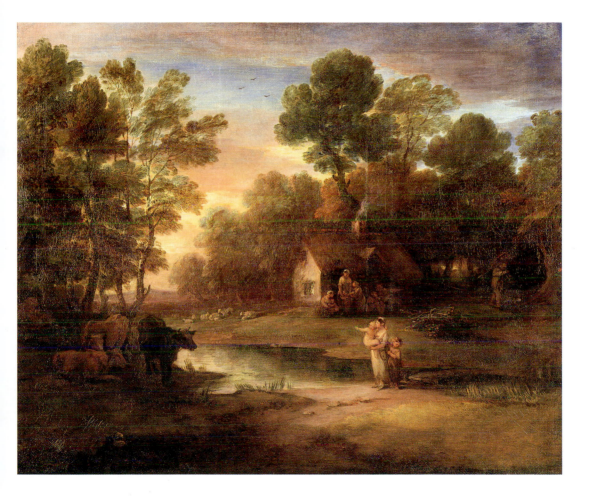

56
The Girl with Pigs
1782

Oil on canvas; 49½ × 58½ in. (125.6 × 148.6 cm)
The Hon. Simon Howard, Castle Howard, Yorkshire

Gradually during the 1780s Gainsborough extended his range of subject matter as part of what seems to be an attempt to make his landscapes more respectable and closer to the historical style. The cottage door scenes extended their emotional range and the figures in them were enlarged to the scale of life.

His *Girl with Pigs* is such a cottager in close-up and is one of the first on this larger scale of what were called his 'fancy pictures'. As Sir Ellis Waterhouse pointed out, however, both Reynolds and Gainsborough often drew from a real model, but 'their poetic character is exactly the same: they are almost the rustic inhabitants of an ideal Arcadia suddenly come to life and sitting for their portraits'. We know that, in fact, Gainsborough also had real pigs 'gambolling about the painting room'.

Reynolds, in a gesture of friendship, was the first purchaser of this picture from the Academy of 1782 for 'a hundred guineas with half as many elegant compliments', to which Gainsborough rejoined, 'I think myself highly honour'd and much obliged to you for this singular mark of your favour: I may truly say, I have brought my Piggs to a fine market.'

The girl with the pigs appeared again on a reduced scale outside a cottage door in a landscape of 1786 (private collection), while Reynolds who thought it 'by far the best picture which he ever painted or perhaps ever will', sold it in 1789, the year after Gainsborough's death.

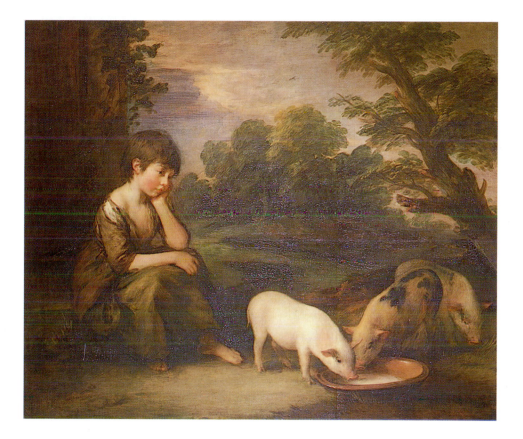

57
The Mall
1783

Oil on canvas; 47½×57⅞ in. (120.6×147.0 cm)
The Frick Collection, New York

At the end of his life Gainsborough retained a fond memory of his 'little Dutch landskips', but his re-creation in English terms of a French rococo style was equally important. He and his fellow artists had imbibed the art of Watteau, in the circle of Frederick, Prince of Wales.

He was to return to this influence again in the 1780s, with this evocation of *The Mall*, called 'Representation of St. James's Park'. According to his friend, William Jackson, 'all the female figures in his Park-scene he drew from a doll of his own creation', and although it was suggested that the figures are portraits, Bate-Dudley, in his review of Gainsborough's exhibition of 1784, said that they are: 'descriptions of characters, women of *fashion*, women of *frolic*, military beaus [sic] and *petits-maîtres*, with a grave *Keeper* or two, and a few accidental *stragglers* to illustrate the representation', which seems nearer to Gainsborough's intention.

When Gainsborough was working on the picture in 1783, Bate-Dudley drew attention, for 'the connoisseur', to the influence of Watteau, 'but ... it is Watteau far outdone'. The figures of Watteau are types from his sketchbooks, and their relationships tender but enigmatic. Here we have the full bustle of a London scene, with the romantic eye contact of Gainsborough's peasant figures translated 'up-market'. This is not a caricature of the smart contemporary scene, however, as Rowlandson had created with his watercolour of Vauxhall, 1784, but 'it is all in motion, and in a flutter like a lady's fan' (Horace Walpole) with the billowing trees closest to the artifice of Fragonard.

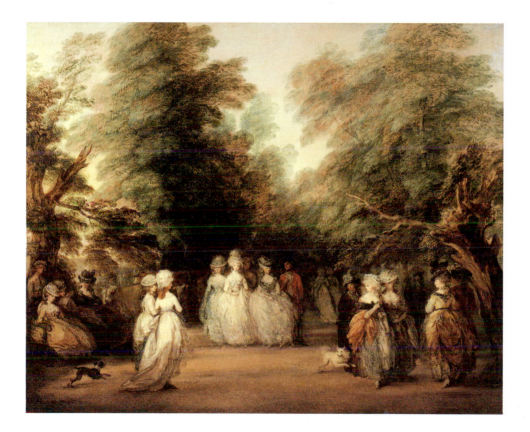

58

Study for a Lady, for 'The Richmond Water Walk' (?)

c. 1785

Black chalk and stump, heightened with white on buff paper; 19⅟₁₆×12¼ in.
(48.4×31.3 cm)

The British Museum, London

This is one of a series of five full-length studies of fashionably dressed women which have been plausibly connected by John Hayes with a projected successor to *The Mall* (Plate 57) for George III. Bate-Dudley mentioned in 1785 that it was to be of 'the Richmond Water-walk, or Windsor … all portraits'. No such picture seems to have been painted, and these studies are not dissimilar to certain full-lengths, on which Gainsborough was also engaged at the same time, namely *Lady Sheffield* (Waddesdon), and the *Duchess of Devonshire* (known from an engraving), as Lindsay Stainton has pointed out in connection with the present example. According to a former owner, William Pearce, a friend of the artist, Gainsborough had been struck by 'the fascinating leer' of a lady when sketching for this subject, but this may have been an invention, as some of the drawings seem to have been drawn from 'dressed dolls'.

Nevertheless, they do seem to perpetuate the mood of *The Mall*, as if Gainsborough had in mind a contemporary version of History painting, on this occasion 'all portraits', to perpetuate the Hampton Court beauties in a scene of modern 'fashionable' life. Certainly, they all continue his fascination with women moving through space, seen from behind (see, for example, Plate 25), or turning towards the spectator, with the drapery and landscape 'all a flutter'.

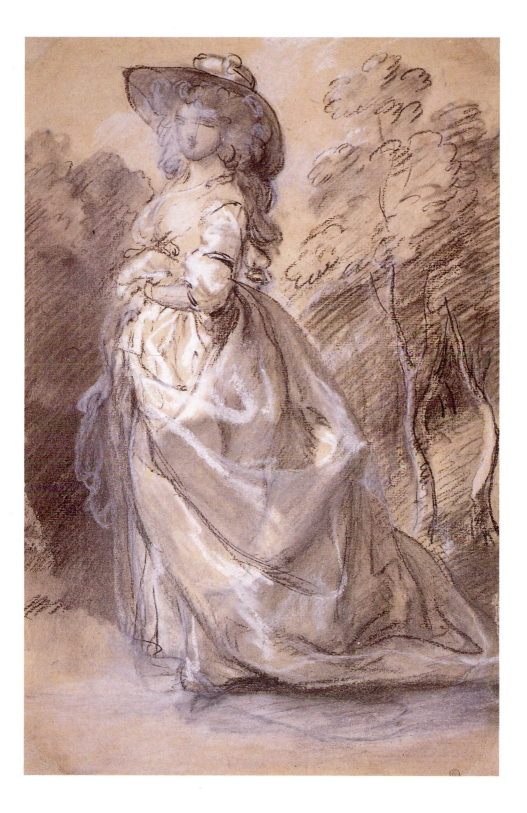

59

Coastal Scene with Sailing Boat and Shepherd

c. 1783–4

Oil on canvas; 25×30 in. (63.5×76.0 cm)

Yale Center for British Art, New Haven

Gainsborough's landscapes into which he put all his imaginative energy were not all commercial successes. This is one which he seems to have sold during his lifetime to a Scotsman.

It develops on a small, presumably more saleable, scale his new seascape theme, combined with an older motif of a shepherd with his flock, leaning on his stick as if praying at a wayside shrine in an Italianate landscape. It is painted thinly all over, with a rapid shorthand for the shepherd, his twisting, attentive dog, and the sheep. The light-grey ground gives an overall tonality, but the purple overtones in the sky and on the boat's sails give a colouristic opposition to the green of the landscape. The effects of *chiaroscuro*, which emphasise the curves of the composition, are achieved by a watercolour technique of glazing which looks forward to nineteenth-century watercolours. The overall effect, in late nineteenth-century aesthetic terms, might be described as 'crepuscular'.

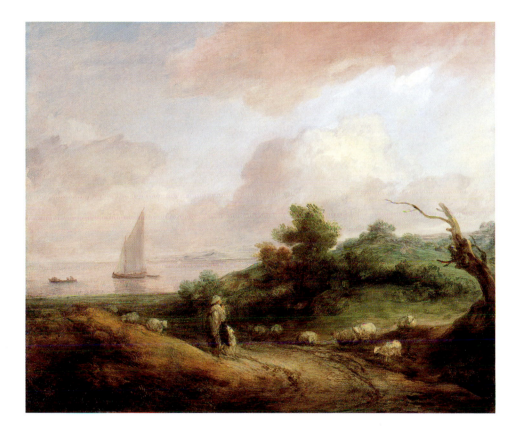

60

Henry Frederick, Duke of Cumberland with his wife, Anne, and Lady Elizabeth Luttrell

c. 1783–5

Oil on canvas; 64½×49 in. (163.8×124.5 cm) oval

Her Majesty the Queen

Gainsborough had painted full-lengths of the royal couple, which were exhibited at the Royal Academy in 1777 (HM The Queen), and he had earlier painted the Duchess when she was Mrs Christopher Horton in 1766 (Dublin, National Gallery of Ireland). This charming and more informal portrait group of Henry Frederick, Duke of Cumberland (1745–90), and his wife Anne (1743–1808), with Lady Elizabeth Luttrell (d. 1799) the Duchess' sister, sketching, was set in Windsor Great Park at Cumberland Lodge and was, apparently, painted at the 'the Duke's instance' between *c.* 1783 and 1785. Curiously, however, it remained unsold, and was bought after the Duke's death, at Mrs Gainsborough's sale in 1792, for the Prince of Wales.

Gainsborough took endless pains over this important commission. There are at least two studies which gradually compress the composition into the highly refined oval we see now. Gainsborough was generally popular with the Royal Family, but, perhaps because it smacks too much of the *demi-monde* represented in *The Mall* (Plate 57), and is too reminiscent of Watteau designs of couples strolling in a garden, such as *La Cascade* (DV28), or *La Promenade* (DV304), or even for the simple matter that it emphasised how much taller Mrs Horton was than the Duke, it was not sold. It remains, however, as a consummate example of his late, highly personal style, where likeness, flattery, and elegant artifice combine.

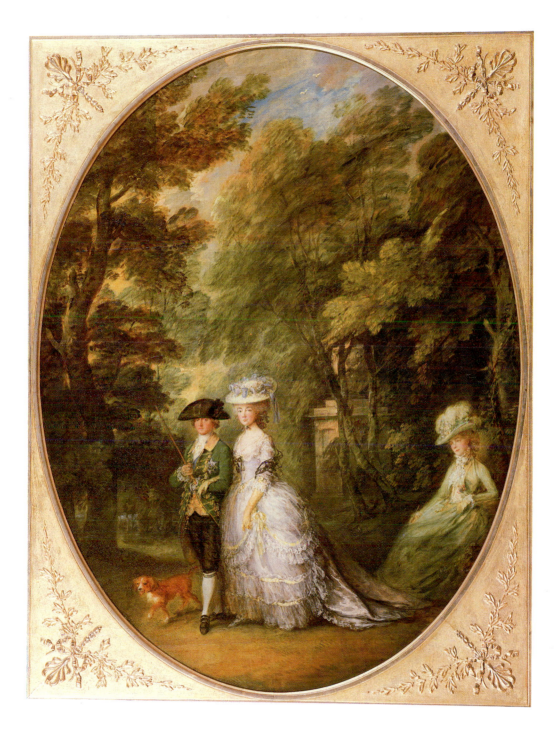

61

Mountain landscape with Peasants Crossing a Bridge

c. 1784
Oil on canvas; 44½×52½ in. (113.0×113.4 cm)
The National Gallery of Art, Washington, D.C.

It was Gainsborough, as certain near contemporaries realised, who may well have had something to do with the mania for the Picturesque which swept over Britain at the end of the eighteenth century. His generalised landscape style aptly fits what his friend, Uvedale Price, was to describe as 'Rough Picturesque'. (For further examples see Plates 43, 55, 72.)

Gainsborough was, in turn, not uninfluenced himself by this contemporary fashion, visiting the West Country 'about six years before his death'; there was a possible visit to Wales; and in 1783 he visited the Lake District with his Suffolk friend, Samuel Kilderbee. He proposed to show to another friend, William Pearce, 'that your Grays and Dr. Brownes were tawdry fan painters', which was a sly dig at the poet, Thomas Gray, and Dr John Brown, who had published a description of the lake at Keswick in 1772.

The present painting is one of several whose mountainous scenery and rocky characteristics, even details such as the stone bridge, are reminiscent of the Lake District. One painted for George, Prince of Wales, now in Munich, seems to represent Langdale Pikes, but most, as in the present example, are only generalised remembrances, notable more for their personal mood and flowing compositions, with the paint applied thinly, than for their topographical accuracy.

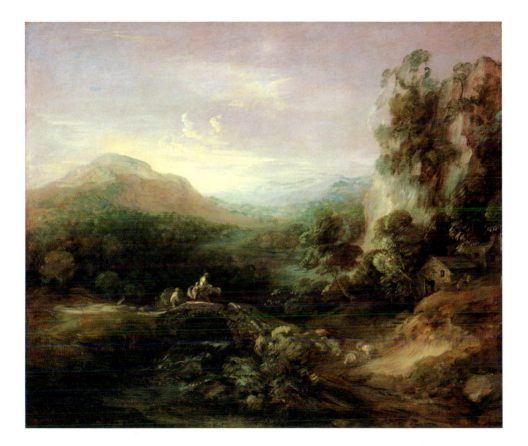

62

Diana and Actaeon

c. 1785

Oil on canvas; 62¼×74 in. (158.1×188.0 cm)

Her Majesty the Queen

His contemporaries and friends agreed that Gainsborough had no pretensions to produce works in a grand historical style (see Introduction, p. 11), but, nevertheless, during his last creative decade of the 1780s he did attempt one major work in this mode which reached the stage of this large sketch. In this oil, for which three compositional drawings are known (see following Plate), he illustrated an episode from Ovid's *Metamorphoses*, where the unwitting mortal Actaeon stumbled on Diana and her nymphs. The goddess has just splashed water on him, so that he has turned into a stag, to be torn to pieces by his own dogs.

Gainsborough was, therefore, forced to behave as an historical painter. He made compositional sketches, which re-arranged the figures, drawing on his visual memory of other versions of Diana and Actaeon, which he could have known through engravings, and from casts of sculpture for some individual figures. Nearly every figure in his drawings and the finished sketch for the picture he never completed can be traced to academic originals. There are poses taken from classical art, Titian, Francesco Albani, and Watteau (see following Plate), but in the last resort Gainsborough has created a highly original and sensitive combination of Old Masters within his own personal evocation of a rococo style. He never produced another essay in this style, but it shows what he might have become as a painter of nude figure compositions. It was bought after his death by the Prince of Wales for the trifling sum of £2 3s.

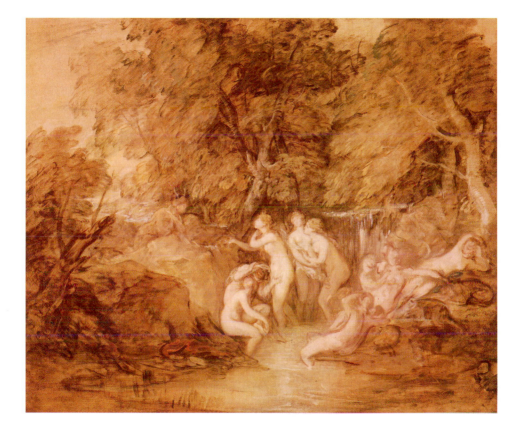

63

Study for Diana and Actaeon

c. 1784–5

Grey and grey-black washes and white chalk on buff paper; 11×14⅐ in.
(27.9×36.7 cm)

Henry E. Huntington Library and Art Gallery, San Marino, California

John Hayes has plausibly arranged the three surviving studies for *Diana and Actaeon* (see previous Plate) in a coherent sequence. The *first*, in the Marchioness of Anglesey's collection, shows the nude figures in disarray as Actaeon appears. The central, active nude figure of Diana appears much the same as she does in all four designs, including the oil sketch, and may be based on a celebrated drawing of *Bathers*, *c.* 1525, by Parmigianino in the Uffizi, which was engraved several times in the sixteenth century. The seated figure between her and Actaeon, with one leg over the other, is in the first drawing, the third (Cecil Higgins Art Gallery, Bedford), and the oil-sketch, but not in the second. The pose is similar to that in Gainsborough's single nude painting of *Musidora* (Tate Gallery) which he may have borrowed from Watteau's *Diana at the Bath*, from the drawing in the Albertina, Vienna, or from the painting in the Groult Collection, or, most likely, from Aveline's print after Watteau's painting. A lead statuette by Adriaen de Vries (*c.* 1545–1626) has also been claimed as a source, but both prototypes ultimately are based on the female figure in a Hellenistic group, *The Invitation to the Dance*, second century BC.

In the present drawing, at the Huntington, the *second* of the series, the number of figures has been reduced but the seated figure at the right with her back half-turned towards the spectator is more or less as she appears in all but the third design. She is based on the figure of Diana in Titian's famous composition of the scene, in 1785 still in the Orléans collection in France, but bought by the Duke of Bridgewater in England, and now on loan to the National Gallery of Scotland from the Duke of Sutherland. She was also used by Francesco Albani in his two paintings of *Diana and Actaeon* in the Louvre, all of which designs were engraved. The ultimate classical source for them all is an antique relief, *The Bed of Policletus* (Rome, Palazzo Mattei).

A noticeable figure in the oil sketch, who faintly appears at the right of the third drawing, is the reclining figure on the bank. She has been compared to a Matisse odalisque, but she is clearly Gainsborough's own version of the famous classical reclining figure of Cleopatra. A figure with her right arm raised who appeared in the first two drawings is no longer in the third, or the oil sketch. She may have been based on a classical sculpture known as *Celestial Venus* in the Uffizi, Florence, a cast of which was in the Royal Academy Schools. A major difference in the third sketch is the figure of Actaeon who starts back, but in all the other versions he leans forward with arms crossed in a gesture of supplication, almost as if he were appearing in an Annunciation, or an Adoration of the Shepherds.

All three drawings are marked by a rapid handling of chalk and wash, with much use of white highlighting.

156

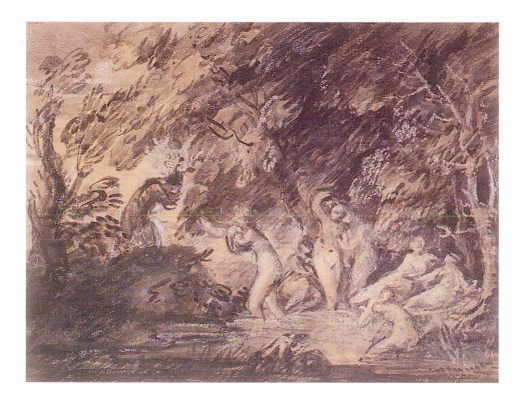

64

The Girl with a Pitcher

1785

Oil on canvas; 68½×49 in. (174.0×124.5 cm)
The National Gallery of Ireland, Dublin

Both Reynolds and Gainsborough contributed original compositions to a class of paintings known as 'fancy pictures', but perhaps the best known, and the one which achieved immediate popularity, was Gainsborough's *Girl with a Pitcher*. It was purchased immediately for 200 guineas by Sir Francis Bassett, and was praised thereafter for its naturalness and simplicity, with the exception of Hazlitt, who thought it had 'a regular insipidity ... to which real nature is a stranger'. Recently, John Barrell claimed that poor children such as these have 'a passport to our heart' because they are seen to be working. We know, however, that this was hardly the case then, and does not answer to our reaction. They were posed in his studio, and in Reynolds', from children who had attracted the eye of the two artists. The girl in this painting had been met by Gainsborough on Richmond Hill carrying the puppy who is so much part of the sentiment of the picture. She seems to be the same girl as the *The Girl with Pigs* (Plate 56).

Ultimately, they were part of the history of taste, inasmuch as they reflect the contemporary interest in Greuze, but they were equally reinterpretations of a gradual eighteenth-century interest in the paintings of Murillo, whose work Gainsborough copied and owned. Murillo's more realistic depictions of peasant boys and girls provide the basis for this single large-scale figure, posed in a picturesque landscape, with a cottage barely visible at the left. Three such images of peasants by Murillo, now at Dulwich, were in the collections of Desenfans and Sir Francis Bourgeois, both close friends of Gainsborough's. *The Flower Girl* who looks directly out at the spectator is particularly close. Murillo's paintings, however, were earthy and frank, and have none of the indirect wistfulness of Gainsborough's more sentimental creations.

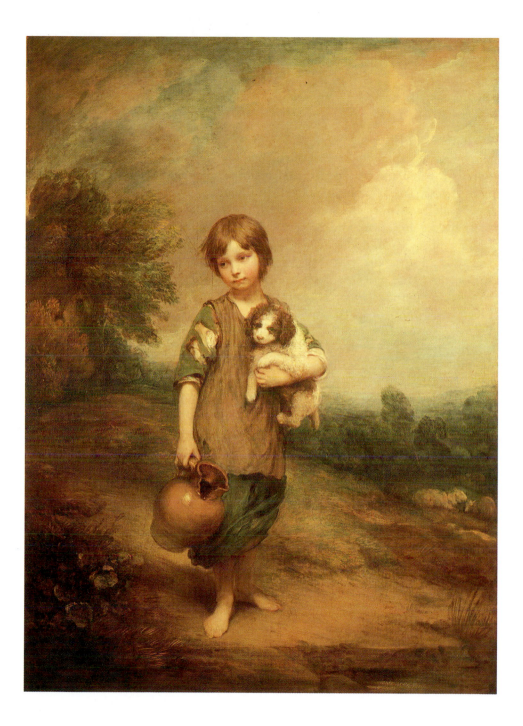

65

Haymaker and Sleeping Girl

c. 1785

Oil on canvas; 89×58½ in. (226.0×148.6 cm)

Museum of Fine Arts, Boston

In a number of late works Gainsborough seemed to revert to ideas which come from his early acquaintance with the French rococo. This particular example is all sentiment, which the rapidly painted landscape emphasises. The courtship scenes of the 1750s (Plate 14) and the example of Boucher have been re-created here on a larger scale, with the haymaker gazing longingly at the sleeping girl, watched warily by the dog. A preliminary drawing is in the British Museum.

Gainsborough's ability to express a stronger emotion than in his earlier works, in this variation on his 'fancy' themes, was probably helped by his study of the Old Masters. There is a hint of a satyr ogling a sleeping nymph, and a reminiscence of Correggio in the reclining pose of the girl which is close, in reverse, to Antiope in his *Jupiter and Antiope* (Louvre). The subtlety of the relationship between the two figures can be appreciated if the painting is compared to the Pre-Raphaelite realistic exegesis of Holman Hunt's *The Hireling Shepherd* of 1851.

Gainsborough Dupont, his nephew and assistant, when offered the choice of any of Gainsborough's recent works, chose this rather than *The Woodman*, which Gainsborough thought a much more important work. Its romantic image and magical effects of light may have appealed to the thirty-year-old artist more than the stern, careworn representation of *The Woodman*.

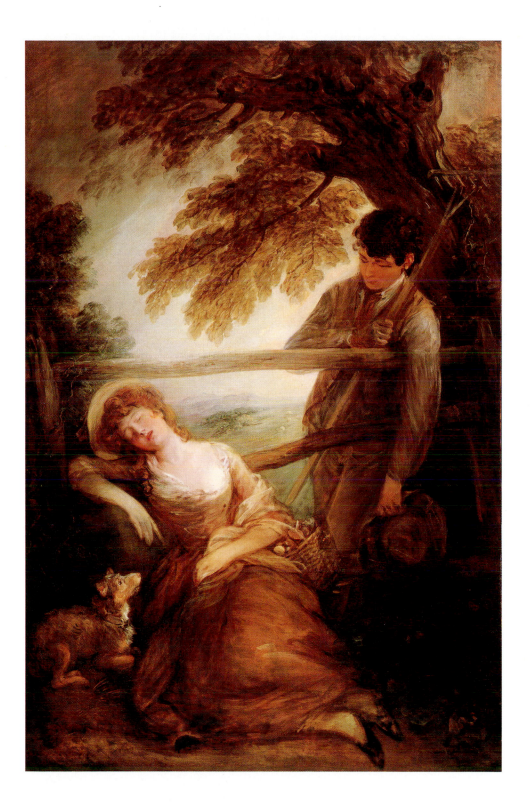

66
Mr and Mrs William Hallett, 'The Morning Walk'
1785
Oil on canvas; 93×70½ in. (236.2×179.1 cm)
The National Gallery, London

The evocative mood of his 'fancy pictures' was also carried over into the portraits with which he was engaged at the end of the 1780s. This embodiment of young married love is a wedding portrait painted in the autumn of 1785, after the marriage of William Hallett (1764–1842) to Elizabeth Stephen (1763/4–1833) in July 1785.

They promenade slowly through the landscape with sidelong glance and attentive Spitz dog, as if they had stepped out, as large as life, from *The Mall* (Plate 57).

The rapidity of handling, particularly in the details of Mrs Hallett's green ribbons and bows, is evident all over, and accompanied by the efflorescence of the landscape and the feathers of her hat.

The French poet Gautier felt intensely 'the illusion of the spirit of the 18th century ... we really fancy we see the young couple walking arm in arm along the garden avenue', but this attitude fitted in well with a nineteenth-century nostalgia for the 1780s.

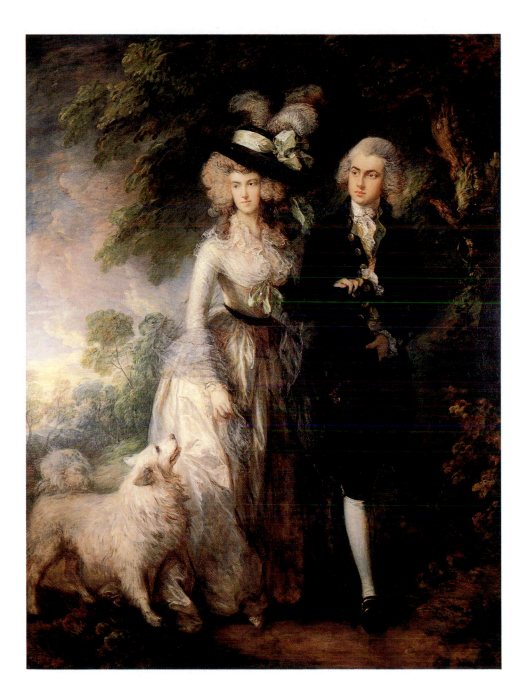

67

Mrs Richard Brinsley Sheridan

1785–6

Oil on canvas; 86½×60½ in. (219.7×153.7 cm)

The National Gallery of Art, Washington, D.C.

Elizabeth Linley (1754–92) was one of the beautiful and talented Linley girls whom Gainsborough had known since their childhood. She was the daughter of Thomas Linley (1732–95), a choirmaster and concert-giver in Bath, and she was to become a musician and leading soprano in her own right. She probably appears in the drawing of *A Music Party* (Plate 38), and she was painted by Gainsborough with her sister Mary as a double portrait of *c*. 1772 (Dulwich College Art Gallery), just before she eloped to France with Richard Brinsley Sheridan (1751–1816). She was to marry him the following year, and she and her family were to be intimately connected with his theatrical ventures.

Here, thirteen years later, in a picture that was probably not quite finished, she appears mature, confident, and even more ethereal than in her earlier portrait. Her windswept hair, fluttering gauze wrap, and blue ribbons are drawn, rather than painted, in strokes that unite the whole surface.

Gainsborough added the sheep in the background the following year which, according to Bate-Dudley, were intended to give the portrait 'an air more pastoral than it at present possesses'. From this we can understand he meant a general pastoral air, rather than any reference to a precise literary allusion, as has been claimed. By means such as this, Gainsborough balanced likeness against a generalised conception, to rank with Reynolds' more literal efforts, such as *Mrs Pelham Feeding Poultry* of 1774 (Lord Yarborough). Gainsborough's late Romantic images look forward, as John Hayes has pointed out, to those of Sir Thomas Lawrence.

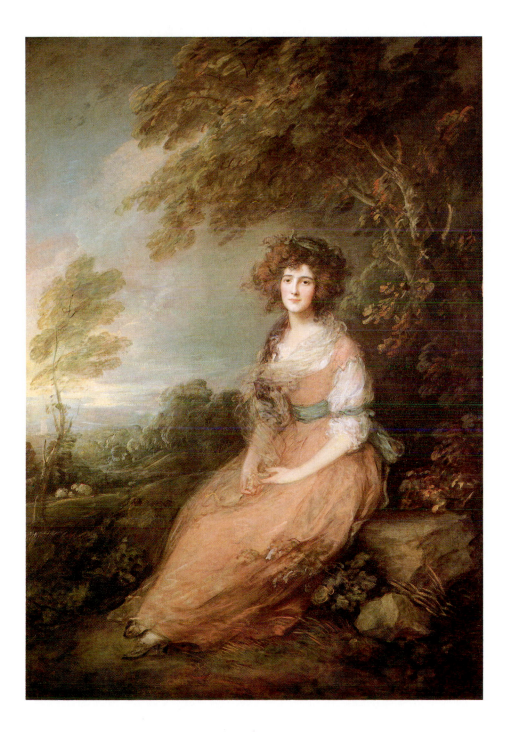

68
The Market Cart
1786

Oil on canvas; 72½×60¼ in. (184.2×153.0 cm)
The Tate Gallery, London

At the very end of his life, Gainsborough produced a series of masterpieces which he realised had achieved a triumph of his art. As he put it more modestly to Reynolds, 'he now began to see what his deficiencies were'. Old motifs do recur, such as the market cart moving down a lane, which looks back to the 1760s, female figures stared at by young men, peasants resting by the wayside, even the old horse which long ago he had modelled in clay, come together in this famous picture.

But now his knowledge of the Old Masters, for example Rubens in the towering baroque composition of the trees and Claude with the effects of light and the distant prospect, are all used in a highly personal synthesis. These references to the Old Masters perhaps endeared it to Sir Peter Burrell (1754–1820), later Lord Gwydyr, who purchased it from Gainsborough (for 350 guineas), and whose portrait he painted in 1787 with a horse in the manner of Reynolds. They also, doubtless, attracted the Governors of the British Institution, who bought it at Lord Gwydyr's sale and presented it to the newly formed National Gallery in 1830.

Gainsborough, however, also looked forward to the new naturalism of Constable. The naturalistic rendering of the trees was commented on by Bate-Dudley who saw it newly finished in December 1786: 'The foliage of the trees, is in a rich variation of lines, expressive of autumn: – here the trees are verdant – a browner aspect there prevails – and all the varied greens and yellows of the season, temper the scene, and exhibit a pleasing harmony.'

As Constable attempted to make something permanent and lasting out of an everyday occurence and casual effects, so Gainsborough equally produced a timeless effect. He has balanced the ephemeral effects of movement and autumnal colouring with a taut composition constructed, as Constable was to do, with strong diagonals beneath the horizon. Even the bending figure of the wood gatherer with his red waistcoat suggests a similar colouristic effect which Constable was to use, for example, in *The Cornfield*, also acquired for the nation.

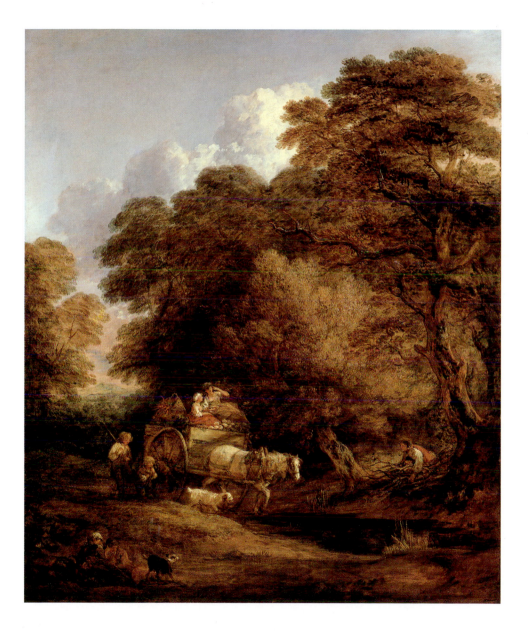

69

Mary, Duchess of Richmond

c. 1786–7

Oil on canvas; 91½× 59½ in. (232.4×151.1 cm)
The National Trust, Rothschild Collection, Ascott

Lady Mary Bruce (1740–96), the daughter of the Earl of Ailesbury, married Charles Lennox, 3rd Duke of Richmond, in 1757. Horace Walpole, her friend and admirer since her childhood, described the marriage as 'The perfectest match in the world – youth, beauty, riches, alliances, and all the blood of the kings from Bruce to Charles II. They are the prettiest couple in England, except the father-in-law and mother.'

The Duke was a patron of the arts and literature, and she keenly supported him in all his activities, including his support of America during the War of Independence, and his liberal aims of universal (male) suffrage, annual Parliaments, and Catholic emancipation. They were both painted by Reynolds and Gainsborough, but whereas Reynolds depicted her dutifully engrossed in her needlework, severely clad in a brown riding habit (1767, Goodwood House), Gainsborough has created a fashionable, aristocratic image in the tradition of Van Dyck, and close to certain full-lengths by Reynolds of the 1780s. The pose and setting hint at the high society at Goodwood.

She holds delicately in her hands the falling arabesque of her blue gauze wrap, as she leans on an overgrown pedestal of an urn. By the constantly fluttering strokes of the highlights on her dress, the ringlets of her hair, and the movement of the foliage, Gainsborough has produced an other-worldly image which is the epitome of his late style. Her introspective turn of the head and slight smile are very personal interpretations of her gentleness and good nature, on which her obituary and Horace Walpole commented after her death.

John Hayes has drawn attention to her elongated arms which may denote the use of a lay figure. In his late portraits Gainsborough achieved a likeness by handling and mood, rather than by careful drawing.

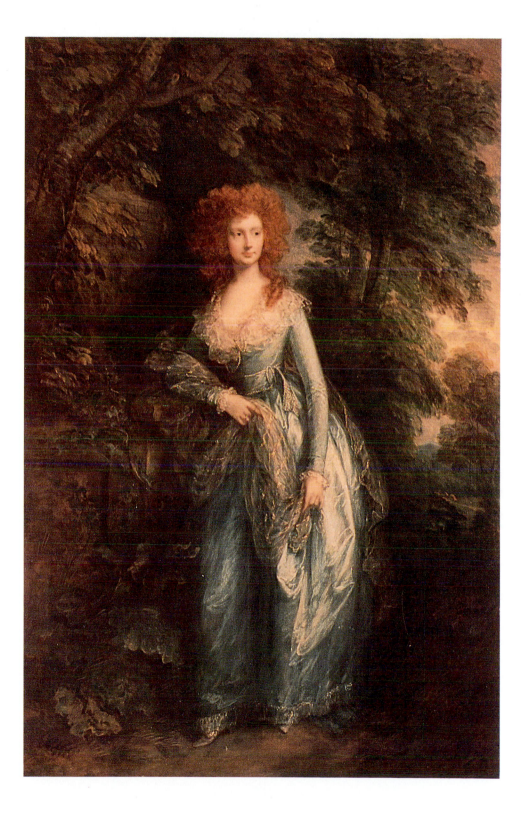

70

Mrs Bate-Dudley

1787

Oil on canvas; 87×57 in. (221.0×144.8 cm)

Trustees of the Burton Property Trust, on loan to the Tate Gallery, London

A certain stern modern taste may well find the portrait of the wife of Henry Bate, later Sir Henry Bate-Dudley, a little bizarre, if not downright silly. Yet Gainsborough's intention must have been to create a sympathetic portrait of the wife of his keenest champion. She was born Mary White, sister of Elizabeth White (1751–1824), the celebrated and beautiful actress known as Mrs Hartley. In 1780, she married Bate, who added the name of Dudley in 1784 (Plate 49) and, by tradition, was painted at his country estate at Bradwell, Essex, in the summer of 1787. He was not created a Baronet until 1813.

Like Lady Richmond (see previous Plate), she is leaning against an urn in a woodland, which suggests her husband's estate, but whereas the former was shown in Van Dyck elegance, Lady Bate-Dudley is posed in a pensive mood. She is leaning on her hand with index finger outstretched in a pose which Gainsborough had used in reverse for the portraits of his friend *William Jackson*, 1770, and of *Lady Tyler* of *c.* 1773, and Reynolds had used for his portrait of *Georgiana, Countess Spencer* of 1772, and which had a classical prototype from either the famous Roman fresco of Arcadia at Herculaneum, or a seated figure of Thetis at Pompeii. The figure of Atalanta on an antique sarcophagus of *The Death of Meleager* engraved in 1645, is not dissimilar. The gesture, readily adopted to suggest contemplation, gives the sitter the attribute of a sylvan muse, an approach to portraiture which is close to Reynolds. John Hayes has suggested that she perhaps represents 'Poetry' or 'Sensitivity', but it is not strongly emphasised as it might have been with Reynolds.

In the last resort, the spectator is most impressed by the tumbling drapery, her cascading red hair, loosely covered by transparent silk, her bright blue sash, and the overall nervous touch of paint which gives colour to the foliage and to the flesh tones. As Sir Ellis Waterhouse perceptively remarked: 'considering these pictures as works of art we must abandon all preconceptions about portraiture and judge them as if they were *Nympheas* by Monet'.

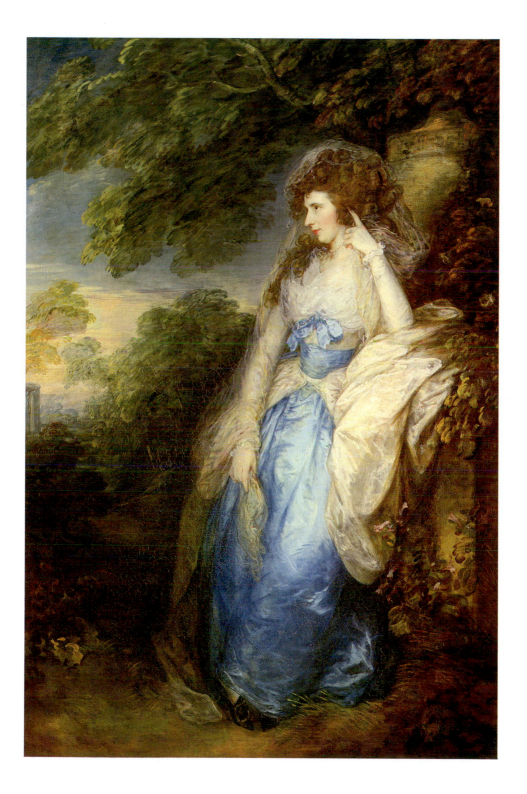

71

Self-Portrait

c. 1787

Oil on canvas; 29½×24 in. (74.9×61.0 cm)
Royal Academy of Arts, London

The contrast between the insouciance of his early *Self-Portrait* (Plate 1) and his searching representation of himself at the age of sixty is clear. The later portrait was probably intended for his friend Abel (Plate 45), who died in 1787, so that he was, presumably, as eager to represent the source of his own art as he had that of Abel's. It was, however, left unfinished. Nevertheless, what we know of Gainsborough's lively interest in country incident, effects of light and dark, the interaction of human beings, his wit and conviviality can all be imagined from his sidelong glance.

It was a picture he thought of highly himself. In June 1788 he decreed that after his

> decease no plaster cast, model, or likeness whatever be permitted to be taken: but that if Mr. Sharp [William Sharp (1749–1824)] who engraved Mr. Hunter's print should choose to make a print from the ¾ sketch [i.e., head and shoulders, generally 30×25 in.] which I intended for Mr. Abel, painted by myself, I give free consent.

His daughter, Margaret, gave it to the Royal Academy in 1808.

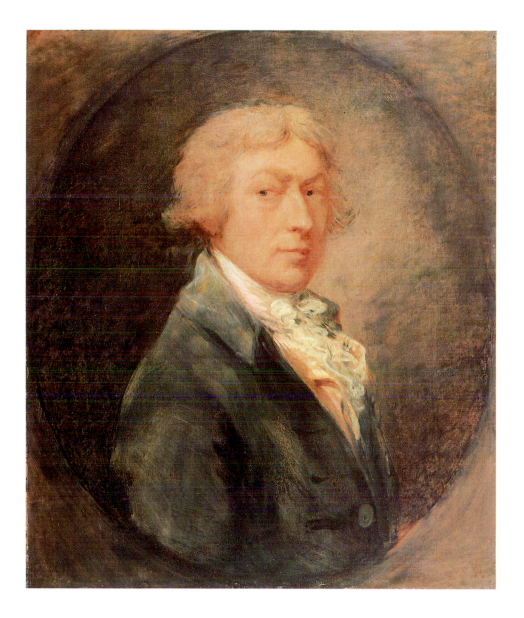

72

A Wooded Landscape with a Castle Gateway and Distant Mountains

c. 1785–8

Black chalk and stump, heightened with white on faded blue paper

$10\frac{7}{16}\times12\frac{5}{16}$ in. (26.5×32.9 cm)

Yale Center for British Art, New Haven

Gainsborough drew throughout his career, as much for relaxation as for any specific composition. In the same way that his late landscape paintings (Plate 43) embodied a general idea of landscape, of effects of space and light, so his drawings were generalised musings of mountains, perhaps remembered from his own 'Picturesque' tour of the Lake District of 1783, with ruined castles and winding roads. They look backwards to the art of Gaspard Dughet, and forward to the amateur's craze for the Picturesque which Jane Austen and Southey were to satirise, but which, of course, Gainsborough had helped to create.

The Rev. William Gilpin, the high priest of the Picturesque, had recommended including 'the castle or the abbey, to give consequence to the scene', of which this might almost be an illustration. Yet the effect of space achieved by inspired improvisations of light and shade were beyond Gilpin's own more conventional efforts.

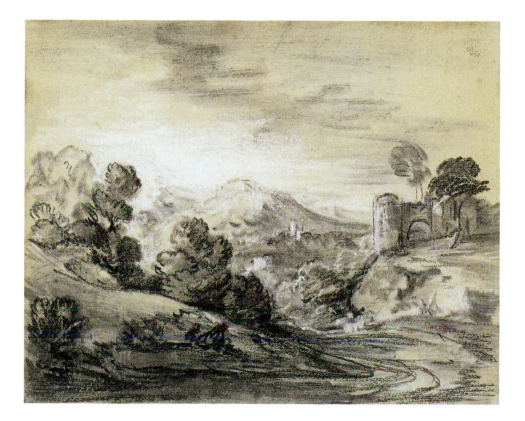

73

Wooded Landscape with Figures, a Cottage, and a Cow

c. 1785–8
Black chalk with grey washes, heightened with white;
10½×15¼ in. (26.7×38.7 cm)
Yale Center for British Art, New Haven

Gainsborough's late drawings can be considered as musical improvisations where, as an amateur musician and professional artist, he could sit down and modulate 'the transitions between sharps and flats', or here between light and dark. This freely executed sketch uses elements from his earlier landscape compositions (Plates 36, 37), with figures and cow moving through a wooded landscape, and with a cottage in the background, but, influenced by his experiments with transparencies, he has used the light tone of the paper to sing through the energetic marks of his brush.

It can be compared to the improvised series of blot drawings by Alexander Cozens (*c.* 1717–86), whose treatise *A New Method of Assisting the Invention of Drawing Original Compositions of Landscapes* had been published in 1786. Cozens, however, as a drawing master, full of theories, was trying to help those with flagging imaginations to make something out of nothing, as it were, by building on the accidental effects of a blot. Gainsborough needed no such aid. His whole private art of drawing, and indeed his finished pictures at the end of his life, were the late creations of a great artist whose imagination found an instinctive and sure touch from within his own experience, to create private moments of pure visual effects.

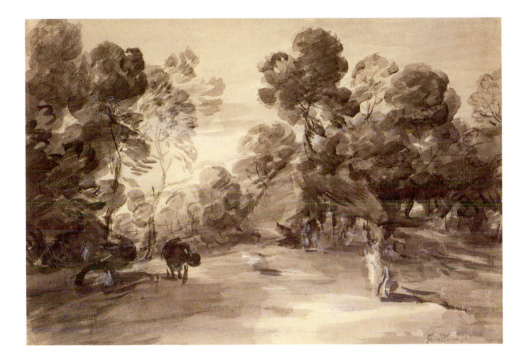

74

A Wooded Landscape with Figures by a Pool

c. 1788

*Black chalk and stump, with touches of red chalk, grey and brown washes with
some body colour on buff paper; 15½×12½ in. (39.4×31.7 cm)*

Yale Center for British Art, New Haven

Gainsborough very rarely prepared elaborate compositional drawings for a
particular picture (Plates 58 and 63 for rare examples). It was as if the themes that
occupied him at any moment could be expressed as drawings or pictures, and his
elaborate techniques could blur the differences between sketch and finished oil
paintings (Plates 36, 37).

This was a drawing, however, which was expanded into a finished picture
known as *Peasant Smoking at a Cottage Door* (see following Plate), painted
during his last illness in 1788. The drawing, which makes much use of rubbing
with stump and the buff paper as a unifying tone, has been compared by
Christopher White with drawings by Anthonie Waterloo whose works Gains-
borough admired. Gainsborough's technique, however, is much more varied and
emphemeral in effect.

The figures are drawn, paused beside a pool, to provide a gleam of light which
Gainsborough liked to exploit, and the peasant is sitting on cut branches. He is
close in pose to a drawing from the life of 'a poor smith worn out by labour',
whom he used as a model for his famous paintings of *The Woodman* (destroyed
by fire in 1810).

In the finished picture the mood is more optimistic. They are at ease before their
cottage door (see also Plate 51), with the peasant shown younger, and less
decrepit, smoking his pipe with a jug of ale in his hand, and his family before him.
Nevertheless, the dead tree at the right, the trees at the left, and the distant
mountainous landscape are carried over from the drawing to the finished picture.

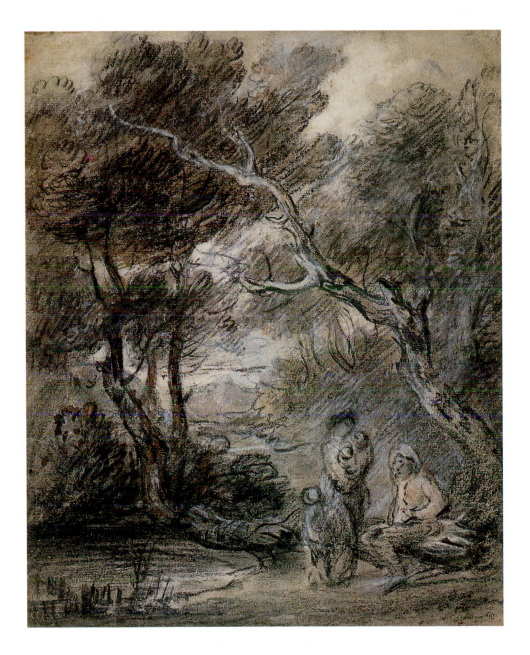

75

Peasant Smoking at a Cottage Door
1788
Oil on canvas; 77×62 in. (195.6×157.5 cm.)
University of California, Los Angeles

This, the largest of Gainsborough's landscapes, was painted in the last months of his life. It was intended as a pendant to his *The Market Cart* (Plate 68), and was completed by candlelight. That he set great store by it can be judged from the high price of 500 guineas asked for in his posthumous sale of 1789. It remained unsold, and was eventually bought by Sir George Beaumont for about 250 guineas.

In this late masterpiece his obsession with cottage door scenes and rustic pastoral are combined and concentrated from a preliminary sketch (see Plate 74). It is an image of contentment, lit by a soft evening light, which marks the summation of his highly personal style. Yet its sentiment echoes, as John Barrell has pointed out, the contemporary ideas of William Paley, *Reasons for Contentment Addressed to the Labouring Part of the British Public*, 1792:

> If the face of happiness can anywhere be seen, it is in the summer evening of a country village, where, after the labours of the day, each man at his door, with his children, amongst his neighbours, feels his frame and his heart at rest, every thing about him pleased and pleasing, and a delight and a complacency in his sensations far beyond what either luxury or diversion can afford. The rich want this; and they want what they must never have . . .

They (the rich, that is) may have liked the general sentiment, but they did not buy representations of it from Gainsborough. His landscapes, in the years immediately following his death, were not well appreciated. Their mood was, perhaps, too personal and generalised, without either the careful delineation that Hoppner seemed to require in 1809 or the sentimental anecdotalism of Wheatley's paintings. Hazlitt thought them affected. It was left to Constable, at the height of the Romantic movement, to appreciate their merits (see Introduction p. 31). Gainsborough's own personal pleasure in observing and painting such scenes owed as much to art as to life, and at the end he drew upon his own sensations, apparently without any moral fervour at the social inequalities which brought such scenes about. ''Tis reading *Poetry*, and compressing all its enchantments to the glance of the eye', as Bate-Dudley described this picture in May 1788.

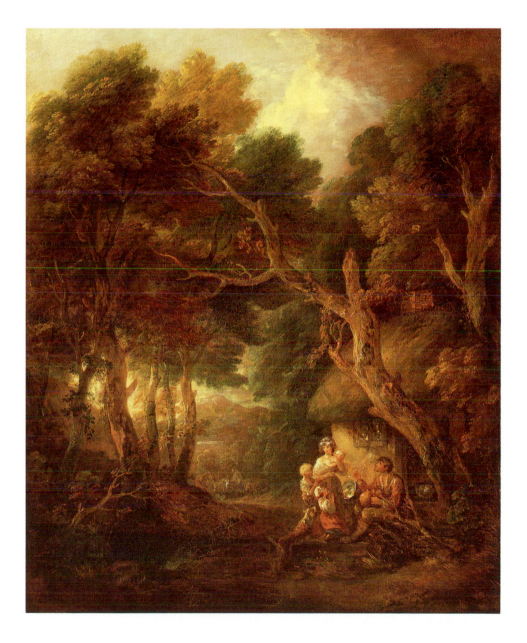

Select Bibliography

Barrell, John. *The Dark Side of the Landscape: The Rural Poor in English Painting 1730–1840*, Cambridge, 1980

Belsey, Hugh. *Gainsborough's Family* (catalogue of an exhibition at Gainsborough's House), Sudbury, 1988

Gainsborough the Printmaker (catalogue of an exhibition at Peter Pears Gallery), Aldeburgh, 1988

Bensusan-Butt, John. *Thomas Gainsborough in his Twenties . . .*, privately printed, Colchester, 1989

Hayes, John. 'British Patrons and Landscape Painting', *Apollo*, 82–6: July 1965, 38–45, March 1966, 188–97, June 1966, 444–51, April 1967, 254–9, November 1967, 358–65

The Drawings of Thomas Gainsborough, London and New Haven, 1970

Gainsborough as a Print-Maker, London and New Haven, 1975

Gainsborough Paintings and Drawings, London, 1975

Gainsborough (catalogue of an exhibition at the Tate Gallery), London, 1980–1

Gainsborough (catalogue of an exhibition at the Grand Palais), Paris, 1981

The Landscape Paintings of Thomas Gainsborough, 2 vols., London and Ithaca, New York, 1982

Hayes, John and Lindsay Stainton. *Gainsborough's Drawings*, International Exhibitions Foundation, 1983

Levey, Michael. '*The Painter's Daughters chasing a Butterfly*', *Painting in Focus 4*, National Gallery, London, 1975.

Lindsay, Jack. *Thomas Gainsborough. His Life and Art*, London, 1981

Paulson, Ronald. *Emblem and Expression: Meaning in English Art of the Eighteenth Century*, London, 1975

Pointon, Marcia. 'Gainsborough and the Landscape of Retirement', *Art History*, 2, no. 4, December 1979, 441–55

Stainton, Lindsay. *Gainsborough and his Musical Friends* (catalogue of an exhibition at Iveagh Bequest, Kenwood), 1977

Waterhouse, Ellis. *Painting in Britain 1530–1790*, 1st ed. 1953 and many subsequent editions, Harmondsworth

Gainsborough, London, 1958

Whitley, William T. *Thomas Gainsborough*, London, 1915

Woodall, Mary. *The Letters of Thomas Gainsborough*, 2nd ed., London, 1963